Masterworks on Paper

FROM THE ALBRIGHT-KNOX ART GALLERY

Masterworks on Paper

FROM THE ALBRIGHT-KNOX ART GALLERY

CHERYL A. BRUTVAN

In Collaboration with

ANITA COLES COSTELLO

HELEN RAYE

HUDSON HILLS PRESS, NEW YORK

In Association with

ALBRIGHT-KNOX ART GALLERY

First Edition

© 1987 The Buffalo Fine Arts Academy
All rights reserved under International and
Pan-American Copyright Conventions.

Published in the United States by Hudson Hills Press, Inc., Suite 1308,
230 Fifth Avenue, New York, NY 10001-7704.

Distributed in the United States, its territories and possessions, Mexico, and
Central and South America by Rizzoli International Publications, Inc.
Distributed in the United Kingdom, Eire, Europe, Israel, and
the Middle East by Phaidon Press Limited.
Distributed in Australia by Bookwise International.
Distributed in Japan by Yohan (Western Publications Distribution Agency).

Editor and Publisher, Hudson Hills Press: Paul Anbinder
Editor, Albright-Knox Art Gallery: Georgette Morphis Hasiotis
Copy editor: Virginia Wageman
Designer: Betty Binns Graphics/Karen Kowles
Composition: Trufont Typographers
Manufactured in Japan by Toppan Printing Company
Photographs are by Biff Henrich, Buffalo, except for figures 2, 3, and 4,
which are courtesy of the Albright-Knox Art Gallery.

Library of Congress Cataloguing-in-Publication Data

Albright-Knox Art Gallery.
Masterworks on paper from the Albright-Knox Art Gallery.

"Published on the occasion of the exhibition 'Intimate Gestures, Realized Visions:
Masterworks on Paper from the Collection of the Albright-Knox Art Gallery,' at the
Albright-Knox Art Gallery, Buffalo, December 12, 1987–January 31, 1988"—T.p. Verso.
Includes index.
1. Drawing—19th century—Catalogues. 2. Drawing—20th century—Catalogues.
3. Drawing—New York—Buffalo—Catalogues. 4. Watercolor painting—19th century—Catalogues.
5. Watercolor painting—20th century—Catalogues.
6. Watercolor painting—New York—Buffalo—Catalogues.
7. Albright-Knox Art Gallery—Catalogues.
I. Brutvan, Cheryl A. II. Costello, Anita Coles. III. Raye, Helen, 1956– . IV. Title.
NC89.A43 1987 741.9′241′074014797 87-3619

ISBN 0-933920-89-X (alk. paper)

CONTENTS

FOREWORD

Works on paper hold a unique, complementary place in the collection of the Albright-Knox Art Gallery, which is known primarily for its outstanding works of modern painting and sculpture. The Gallery's collection of drawings comprises some six hundred works in a variety of media, dating primarily from the mid-nineteenth century to the present. *Masterworks on Paper from the Albright-Knox Art Gallery* is the first catalogue to document this important yet little-known aspect of our collection.

The intimate nature of works on paper can demand sustained attention from the viewer and, as a consequence, perhaps reveals more about an artist's intentions than any other art form. Some drawings were made to be seen as finished works, such as Charles Burchfield's *Mid-June*, 1917–44. More often they serve to illuminate the creative process; their "unfinished," spontaneous qualities reveal explorations and experiments that often find their conclusions in works done in other media. A fine example of this is David Smith's untitled drawing of 1963, which sheds light on *Cubi XVI*, the monumental stainless-steel sculpture in our collection to which it is related. Whether a preliminary study or the record of a moment of inspiration, each of the seventy-five works included here enhances our understanding of the creative process.

The Gallery's ever-increasing commitment to this area of the collection has been demonstrated in many ways over the past decade. A study room for the Department

of Prints and Drawings, completed in 1978 during Robert T. Buck's tenure as director, with Charlotta Kotik as its first curator, has significantly increased public access to the collection of works on paper. In 1980 a public space was renovated with funds from the National Endowment for the Arts, resulting in what is now known as the Prints and Drawings Corridor, a small exhibition space particularly suited to the scale of works on paper.

Essential above all to the development of the collection has been the generosity of several dedicated donors. Two benefactors of exceptional importance—A. Conger Goodyear and Seymour H. Knox—have made significant gifts of American and European works on paper, and any discussion would be incomplete without their mention. Drawings by Henri Matisse, Pablo Picasso, Georges Pierre Seurat, and Charles Sheeler are but a few of the significant works that were donated by A. Conger Goodyear. Given during his lifetime and by bequest, works from Mr. Goodyear provide unequivocal evidence of his superb connoisseurship. More recent pieces, including fine examples by Kurt Schwitters, Jim Dine, and Nancy Graves, among many others, give ample testimony to Seymour H. Knox's keen devotion to contemporary art in all its aspects and to a generosity that continues to enrich our holdings immeasurably.

It is with special gratitude that I acknowledge the fine efforts of Cheryl A. Brutvan, associate curator in charge of prints and drawings. A passionate and knowledgeable lover of these media, she has accomplished the first major evaluation of our collection of works on paper. She has been capably assisted in the preparation of the catalogue by Anita Coles Costello, Ph.D., and by Assistant Curator Helen Raye. All three authors have made valuable contributions to our understanding of these works, some of which have never before been published. Georgette Morphis Hasiotis, editor of publications, has completed the editing and organization of the material with admirable skill.

As one in a series of publications devoted to documenting our permanent collection, this volume joins *Contemporary Art 1942-72* (1972), *Painting and Sculpture from Antiquity to 1942* (1979), and *The Painting and Sculpture Collection: Acquisitions since 1972* (1987), which catalogue major works of painting and sculpture. It also accompanies "Intimate Gestures, Realized Visions: Masterworks on Paper from the Collection of the Albright-Knox Art Gallery," the final exhibition in our year-long celebration during 1987 of the 125th anniversary of the founding of the Buffalo Fine Arts Academy, the parent organization of the Albright-Knox Art Gallery.

The generous and farsighted support of this publication by Seymour H. Knox, whose contributions to the Gallery are already inestimable, has enabled us to bring this significant aspect of our collection to a wider audience, and for this we are extremely grateful to him.

DOUGLAS G. SCHULTZ
Director, Albright-Knox Art Gallery

ACKNOWLEDGMENTS

This volume premieres a selection of the Albright-Knox Art Gallery's collection of unique works on paper. It would not have been possible without the commitment and enthusiasm of several individuals. The support of Seymour H. Knox, whose devotion to this institution continues to influence its direction profoundly, has been crucial to the realization of our dream to research and publish this largely unknown area of the Gallery's permanent collection. I am deeply grateful to Douglas G. Schultz, director, for his advice and steadfast support, which were essential to the materialization of this volume.

The involvement of scholars was critical to the creation of this volume. Dr. Anita Coles Costello researched her subjects with keen interest, resulting in entries that sensitively address these masterworks. The eloquent texts by Assistant Curator Helen Raye are invaluable additions, as was her experience throughout every stage of the project. The research accomplished by Dr. Steven A. Nash during his years of association with this museum was indispensable. Much support and expert advice on drawings were generously given by Sandra H. Olsen, director, Buscaglia-Castellani Art Gallery, Niagara Falls, New York. The expertise of conservators from the Intermuseum Laboratory, Oberlin, Ohio—especially Joan Gorman, Robert Lodge, and Gina McKay—was vital to the accurate documentation of each work. Dr. Melissa Banta generously assisted throughout all stages of this project, for which I am es-

pecially grateful. Other scholars who contributed to this collection include William C. Agee; Nicolai Cikovsky, Jr., curator of American art, National Gallery of Art, Washington, D.C.; Robert Herbert and Matthew Druitt of Yale University; and Dr. Jeffrey Hayes of the University of Wisconsin—Milwaukee. The cooperation of several commercial galleries was fundamental to increasing our knowledge about work in this volume; troublesome questions of provenance and dating were answered without hesitation. We are grateful to Carus Gallery; Suzanne Hilberry Gallery; Hirschl & Adler Galleries; Kraushaar Galleries; Barbara Mathes Gallery; Pierre Matisse Gallery; Washburn Gallery; and Willard Gallery.

We are especially pleased that a selection of the masterworks in this catalogue will be circulated as an exhibition by the Gallery Association of New York State. Kevan N. Moss, executive director, and Constance A. Klein, exhibitions coordinator, have been enthusiastic in arranging an appropriate and impressive tour.

The interest and aid that so many people have generously contributed to this project have made it possible and enjoyable. I offer my heartfelt thanks especially to my family and friends for their interest in and support of my efforts. The following people on the staff of the Albright-Knox Art Gallery were particularly helpful: Leta K. Stathacos, former marketing coordinator, was an early supporter and was pivotal in bringing this publication to fruition; Biff Henrich photographed the works in his accustomed style with great skill and good humor. Aiding him in this task were members of the installation crew, particularly Zbynek Jonak. Also of great aid were Michael Auping, chief curator; Annette Masling, librarian; Judith Joyce, assistant editor; Laura Catalano, registrar; Alba Priore, assistant registrar; Lenore Godin, Gallery Shop manager; and Barbara Barber, development officer.

Georgette Morphis Hasiotis edited the manuscript with an appreciation for the subject, great enthusiasm, and sensitivity; her contribution to the success of this volume goes beyond mere thanks. Paul Anbinder, editor-in-chief and publisher of Hudson Hills Press, and his able staff are to be commended for their considered handling of this project. The classical design by Betty Binns Graphics has resulted in a publication of which we are all proud.

CHERYL A. BRUTVAN

INTRODUCTION

The development of the Albright-Knox Art Gallery's collection of unique works on paper has quietly paralleled that of its better-known collection of painting and sculpture. However, few of the extraordinary examples of works on paper are known to those outside our immediate audience. Each year since 1905, acquisitions have been listed in the Gallery's *Annual Report*, and some modern European and American works on paper were addressed by Steven A. Nash during his tenure at the Gallery as chief curator and were published in the 1979 collection catalogue *Painting and Sculpture from Antiquity to 1942*. The designation of a study room and the creation of an exclusive exhibition space have furthered public awareness of this part of the permanent collection, and it now seems fitting that we make these fine works accessible to a still wider audience in a publication devoted solely to works on paper.

Masterworks on Paper from the Albright-Knox Art Gallery has been written to serve the needs of scholars and the interests of a general audience. The seventy-five masterworks in this volume, all reproduced in color, were selected as representative of the Gallery's holdings. The works have been arranged in a loosely chronological sequence, allowing for aesthetic and formal considerations.

The collection of works on paper reflects the Gallery's interest in modern art and in works by artists of the twentieth century. Yet despite this decided emphasis, the

Gallery is not without remarkable examples predating 1900. In fact, the first drawings acquired were a generous gift of Frederick H. James (1825–97), a resident of the Buffalo area and a director of the Buffalo Fine Arts Academy in 1894. His outstanding gift in 1891 of over two hundred etchings and four drawings by Sir Francis Seymour Haden resulted in the establishment of the Department of Prints and Drawings. *The Colosseum*, 1843–44 (fig. 1), one of the four drawings in this first gift, reveals the artist's visual acumen and the superb mastery of line for which his graphic work is admired.

Efforts to round out the collection of works on paper were greatly advanced during the tenure of Gordon Washburn, director of the Albright Art Gallery from 1931 to 1942. In an attempt to strengthen the collection by expanding its breadth, acquisitions under his stewardship included an exceptional work by Canaletto entitled *View through an Arch of Westminster Bridge*, c. 1746–55 (fig. 2), and the exquisite *Portrait of Madame Simart*, 1857, by Jean-Auguste-Dominique Ingres, the earliest masterwork included in this volume. Continuing in this pursuit, the Gallery has been fortunate indeed to have acquired a sanguine drawing by François Boucher, *Seated Female Nude*, c. 1738 (fig. 3), in 1953; and an intimate oil study by Sir Joshua Reynolds, *Sketch for the Portrait of Mrs. Billington as Saint Celia*, 1789 (fig. 4), was received in 1982 from the Stevens family in memory of Mary Reed Stevens.

Adventurous and visionary, the Room of Contemporary Art Fund was as pivotal to the development of our collection of works on paper as it was to our famed collection of painting and sculpture. Established in 1939 through the generosity of Seymour H. Knox, members of his family, and seventeen art enthusiasts, the Room of Contemporary Art was a pioneering program for the collecting of contemporary art that helped secure the Gallery's focus on *modern* art. Guided by Director Gordon

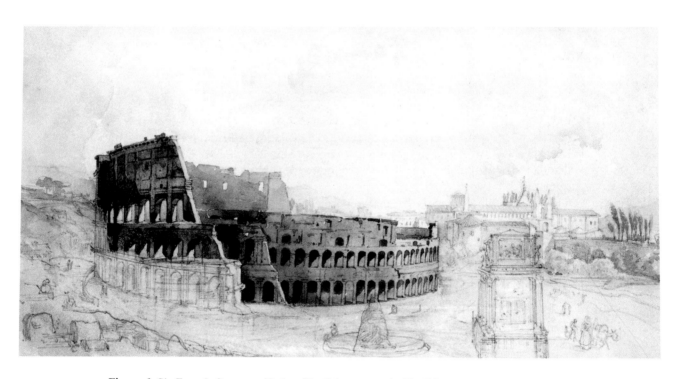

Figure 1 Sir Francis Seymour Haden (English, 1818–1911). *The Colosseum*, 1843–44. Pencil and watercolor, 6⅛ x 12¼ (15.5 x 31.1). Gift of Frederick H. James, 1891.

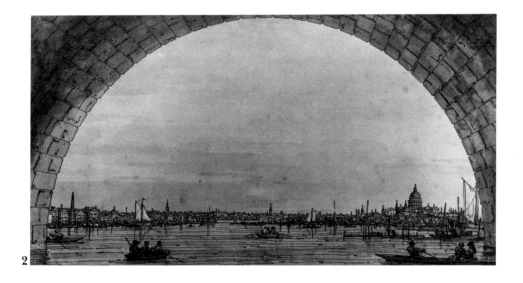

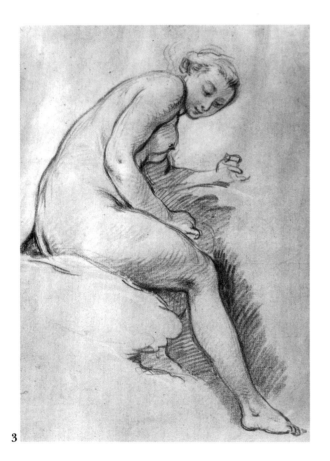

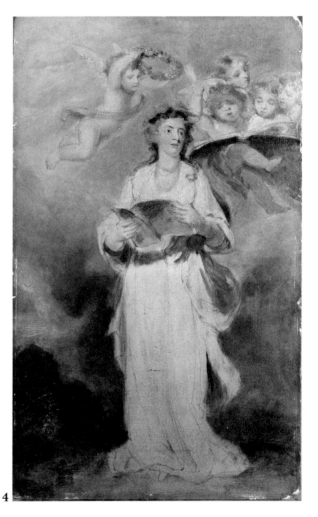

Figure 2 Canaletto (Italian, 1697–1768). *View through an Arch of Westminster Bridge*, c. 1746–55. Pen and ink and wash, 11⅛ x 20⅝ (28 x 52.4). Elisabeth H. Gates Fund, 1958.

Figure 3 François Boucher (French, 1703–70). *Seated Female Nude*, c. 1738. Sanguine, 11⅜ x 8¼ (28.9 x 20.9). Charlotte A. Watson Fund, 1953.

Figure 4 Sir Joshua Reynolds (British, 1723–92). *Sketch for the Portrait of Mrs. Billington as Saint Celia*, 1789. Oil and pencil, 17¹⁵⁄₁₆ x 10¹⁵⁄₁₆ (45.4 x 27.7). Gift of the Stevens family in memory of Mary Reed Stevens, 1982.

Washburn and Board member Philip Wickser, the group purchased works by Paul Cézanne, Odilon Redon, Pablo Picasso, and Paul Klee, as well as examples by American Modernists Maurice Prendergast, Charles Demuth, Reginald Marsh, and Mark Tobey, through a fund distinct from the Academy's. Several of their farsighted acquisitions are included in this volume.

Numerous patrons have been instrumental in the formation of this collection, and they cannot be sufficiently thanked for their generosity. Outstanding among them is A. Conger Goodyear, whose passion as a collector is evidenced by the extraordinary works he gave to the Gallery during his lifetime and by bequest.

In honor of his mother, Martha Jackson, a native of Buffalo who promoted the works of Abstract Expressionist and Pop artists in her New York gallery, David K. Anderson and his wife, Becky, established the Martha Jackson Collection at the Albright-Knox Art Gallery. Comprising works in all media and including important drawings, the Martha Jackson Collection reflects its namesake's tastes and is an enduring tribute to her affection for the Gallery.

Seymour H. Knox, president of the Board of the Buffalo Fine Arts Academy from 1938 to 1977, chairman from 1977 to 1985, and currently honorary chairman, remains the quintessential patron of our collection. His devotion to modern and contemporary art has made possible the celebration of our collection of masterworks on paper in this elegant volume. Through the generosity of Seymour H. Knox and others, this part of the collection continues to expand, assuming new meaning and importance as it grows.

CHERYL A. BRUTVAN

NOTE TO THE READER

Dimensions are given in inches (and centimeters), height preceding width. Dimensions indicate support size unless otherwise noted. Only the sheet is illustrated; support mounts are not shown.

Initials at the end of each entry indicate authorship:
CB Cheryl A. Brutvan, Associate Curator in Charge of Prints and Drawings, Albright-Knox Art Gallery
AC Anita Coles Costello, Ph.D.
HR Helen Raye, Assistant Curator, Albright-Knox Art Gallery

Masterworks on Paper

FROM THE ALBRIGHT-KNOX ART GALLERY

JAMES MCNEILL WHISTLER

American, 1834–1903

Old Battersea Bridge, c. 1871

An incessant and passionate draftsman, James McNeill Whistler admitted privately to feeling insecure about his skills despite early evidence of his "uncommon genius."[1] He mastered several media and excelled in the graphic arts, earning an international reputation for his etchings during his lifetime. Although well traveled, Whistler lived most of his life in London and was associated with the most progressive of European artists. He joined the Impressionists in their enthusiasm for things oriental, especially design concepts found in contemporary Japanese work. He regularly scheduled evening boating trips on the Thames in order to sketch, and the images he discovered during these outings inspired his controversial *Nocturnes*.

Whistler frequently rendered familiar subjects like Battersea Bridge. It appears in charcoal in this sketch, but he also depicted it in pastel, paint, etching, and lithography. This drawing is believed to be a preliminary study for *Blue and Silver: Screen with Old Battersea Bridge*, 1872, a painted screen whose enigmatic nighttime image spanning two panels was a favorite of the artist.[2]

In subject and composition, Whistler's debt to Japanese woodcuts and design concepts is evident in the Gallery's work; the placement of the bridge's looming support encourages a reading of flattened space in a vertical composition, which is emphasized further in the later painted screen. The moon, found on both sides of this two-sheet study as a simple circular shape, appears finally at right in the screen; it is eclipsed by a horizontal band that is no longer distinguishable as a railing with passers-by. Color is hinted only in the highlights of gray that animate the support of the bridge.

Whistler's attention to detail aids in the assignment of a date for this work; visible in the background is the Albert Bridge under construction, a project begun in 1871 and completed in 1873.[3] The use of two pages for this study may have been an attempt by the artist to test the success of the composition as a folding image.[4] CB

1 Phoebe Lloyd, "Anna Whistler the Venerable," *Art in America* 72, no. 10 (Nov. 1984): 140, 144.

2 Andrew McLaren Young et al., *The Paintings of James McNeill Whistler* (New Haven and London: Yale University Press for Paul Mellon Centre for Studies in British Art, 1980), p. 85.

3 Ibid.

4 Letter from Michael Komanecky, author of *The Folding Image* (New Haven: Yale University Art Gallery, 1984), to Douglas G. Schultz, 6 Apr. 1983, in the Gallery files.

Charcoal, chalk, and wash on brown, pieced paper
10⅝ x 14 (27 x 35.5)
Inscribed center right in charcoal: monogram of artist
Inv. no. 1958:1.3
Gift of George F. Goodyear

Provenance: George F. Goodyear, Buffalo; presented, 1958.

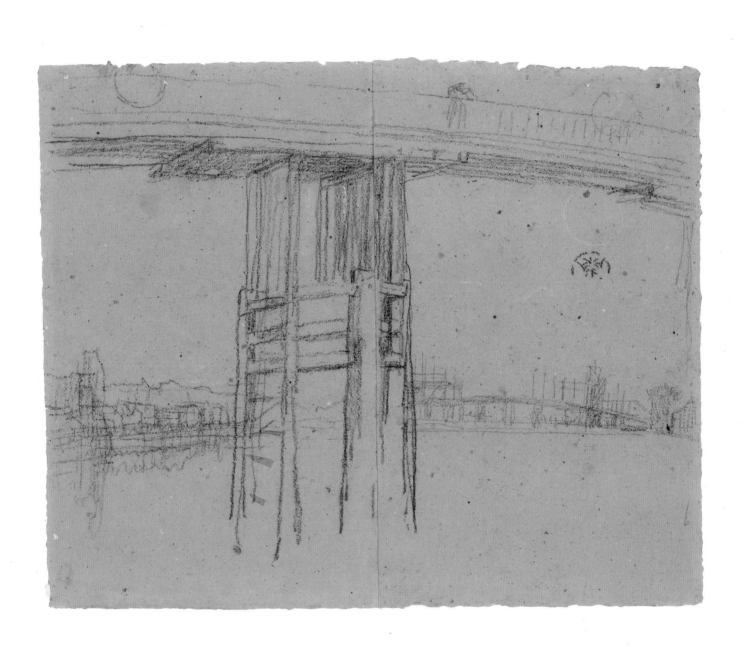

WINSLOW HOMER
American, 1836–1910

Woman and Elephant, c. 1877

When Winslow Homer first seriously began working in the medium of watercolor in 1873 he was already well established as a commercial illustrator and was gaining recognition for his oil paintings. Over the next thirty-two years he would, however, challenge and extend the boundaries of the watercolor medium, producing works that remain unsurpassed in the history of American art.

Homer received consistent critical attention for his first efforts in watercolor; however, most of it focused on their unfinished appearance. This unconventional aspect of his work resulted from the methods he employed, including an energetic application of paint on an unprepared dry page that allowed untouched areas to remain visible and the layering of transparent washes to build up color.

In 1875 Homer ended his commercial-art career and began a series of watercolors, polished in execution and conventional in subject, that reflected his interest in exploring figurative images and his new devotion to painting. *Woman and Elephant* is among several works dating from the late 1870s in which Homer portrayed a removed and pensive Victorian woman. The artist has limited his palette to somber tones with unexpected splashes of brilliant color. Also evident is the sensitive rendering of this particular model, whom Homer frequently depicted looking away from the viewer, as in *Woman and Elephant*. With transparent washes the artist subtly and lovingly defined her features.

Typical of the period was a growing curiosity with things exotic, as represented here by the figurine of an elephant. This device allows the addition of color in the composition but also may refer to *L'Inde à Paris*, c. 1867, a widely reproduced and highly praised painting by Alfred Stevens, well known for his lavish and sensitive paintings of Victorian women. Homer would probably have seen the painting at the Exposition Universelle d'Art in Paris.[1] CB

1 William A. Coles, *Alfred Stevens* (Ann Arbor: University of Michigan Museum of Art, 1977), p. 31. Grateful acknowledgment is made to Nicolai Cikovsky, Jr., curator of American art, National Gallery of Art, Washington, D.C., for suggesting the reference to Stevens.

Watercolor
11¾ x 8¾ (29.8 x 22.2)
Inscribed lower right in watercolor: *HOM[ER]*
Inv. no. 1959:4
Gift of Mrs. John C. Ames

Provenance: Augusta K. Rogers, Dedham, Massachusetts; M. Knoedler & Co., New York; A. Conger Goodyear, Buffalo, 1923; Mrs. John C. Ames, New York; presented, 1959.

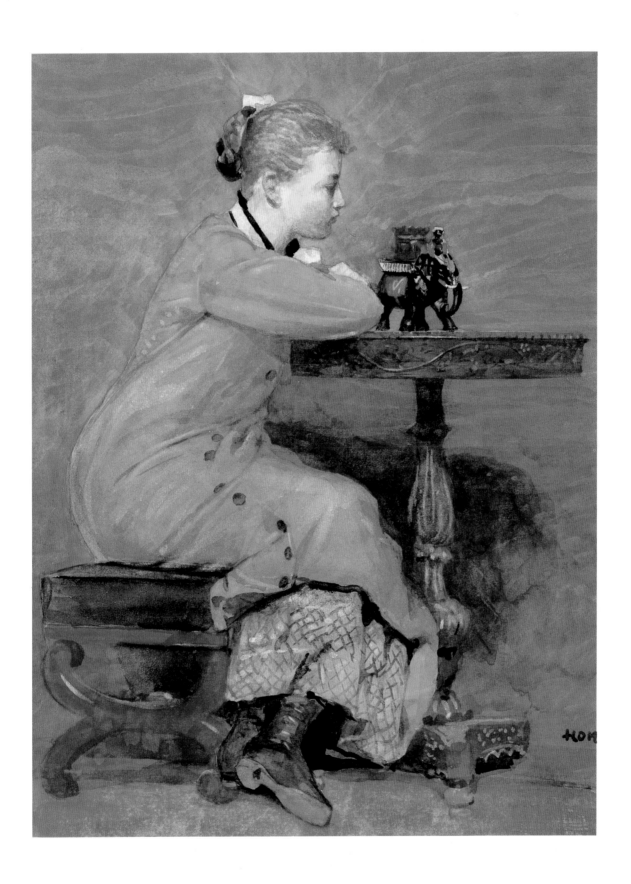

JEAN-FRANÇOIS MILLET

French, 1814–1875

La Naissance du veau (Bringing Home the Newborn Calf), c. 1860

L *a Naissance du veau (Bringing Home the Newborn Calf)* is one of seven known preparatory drawings by Jean-François Millet for two oil paintings bearing the same title. The final painting, now in the Art Institute of Chicago, was executed in 1864. The Gallery's drawing is probably a study for the smaller unfinished oil sketch of about 1860[1] and, on the basis of the related drawings, should be dated to the same time.[2] Unlike the more elaborate compositional studies in the group, in this work Millet concentrates on refining the poses of the men. He commonly made many sketches for his paintings, often tracing figures and making subtle alterations in gestures or poses until satisfied with the image.[3] His particular concern with perfecting the figures portrayed in the Gallery's work is borne out by two closely related sketches. One depicts the two peasants with an empty litter, while the other includes only the leading figure. Poses in all three versions are close, slight differences occurring only in such minor details as the positions of the feet and the contours of the hats.

Full bodied and sensitively rendered, the peasants in the Gallery's drawing move in a silent procession, their curved backs and measured steps eloquently conveying the weight and fragility of their burden. The solemn, almost sacramental quality that has often been noted in the paintings is also present in the drawing. By omitting the bucolic setting and anecdotal details found in the paintings, Millet focuses attention on the figures. Plainly dressed, their faces in shadow, the peasants remain anonymous. Monumental in conception, they evoke an ideal and reflect Millet's belief in their inherent dignity. In this simple drawing he elevates a common rural event to the level of a symbolic rite. AC

[1] Private collection; see John Minor Wisdom, *French Nineteenth-Century Oil Sketches: David to Degas* (Chapel Hill, N.C.: William Hayes Ackland Memorial Art Center, 1978), pl. 50.

[2] Letter from Robert L. Herbert to the author, 1 Oct. 1986, in the Gallery files. Herbert notes, however, that Millet "often reworked portions of a composition when enlarging it," raising the possibility that one or more of the figural studies may have been done for the larger painting of 1864 (Art Institute of Chicago).

[3] Robert L. Herbert, "Millet Reconsidered," *Museum Studies* 1 (Art Institute of Chicago, 1966): 38–39, 61; see also idem, *Jean-François Millet* (London: Arts Council of Great Britain, 1976), p. 144.

Charcoal on blue paper [faded]
7¼ x 10¼ (18.5 x 26)
Inscribed lower center in ink: *JFM*
Inv. no. 1954:1.3
Gift of A. Conger Goodyear

Provenance: Leicester Galleries, London; A. Conger Goodyear, Buffalo, 1923; presented, 1954.

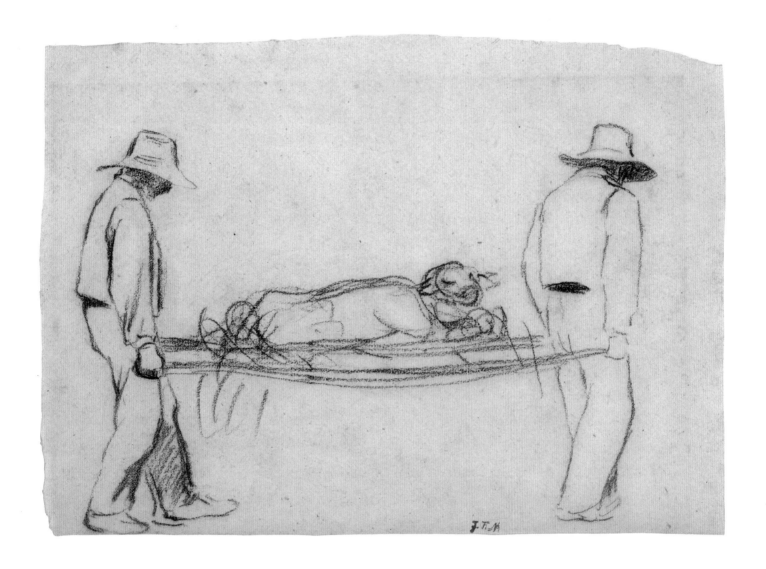

JEAN-AUGUSTE-DOMINIQUE INGRES

French, 1780–1867

Portrait de Mme Simart (Portrait of Madame Simart), 1857

From an early date, Jean-Auguste-Dominique Ingres was justly admired for his remarkable ability to capture a likeness on paper. Over 450 portrait drawings are known. Commissioned pencil portraits provided him with a vital source of income during a long sojourn in Italy from 1806 to 1824. Even after his return to Paris in 1824, Ingres continued to execute drawings of friends and family. As a group these personal drawings are not as elaborate or as highly finished as the commissioned portraits, yet they are unsurpassed in Ingres's work for their insightful revelations of character.

Despite the inscription dedicating the work to his friend "Simard," this drawing has been convincingly identified as a portrait of Amelie Baltard Simart, the second wife of Charles Simart (1806–57), a successful sculptor and acquaintance of Ingres.[1] In 1857, the same year Ingres executed the drawing, Simart died from injuries suffered in an accident, leading to speculation that Ingres may have drawn this portrait of Simart's wife to cheer him as he lay ill.[2]

Executed rather late in his career, *Portrait de Mme Simart (Portrait of Madame Simart)* is a striking example of Ingres's singular skill as a draftsman and a portraitist, a skill seemingly undiminished by advancing age. Working on thin, transparent paper with a smooth matte surface, Ingres characteristically manipulated his pencil to achieve a variety of line and tonal effects. He is believed to have favored a chisel-shaped point, which would have allowed him to vary the width of his stroke without changing pencils. In some instances he is known to have used more than one pencil in a single work.[3] At least two grades of graphite pencil appear to have been used in the Gallery's drawing. The major portion was executed with a single pencil of varying sharpness and definition, while the hair and face show evidence of a softer grade of pencil. The metallic luster of the hair is due to Ingres's reworking of the area. His distinctive technique directs attention to the sitter's fully modeled head. For all their beauty, the elaborate gown and the fine, sensitive hands are overshadowed by Madame Simart's exquisitely rendered face. AC

1 Letter from Hans Naef to the Albright-Knox Art Gallery, 27 Jan. 1953, in the Gallery files. See also Agnes Mongan and Hans Naef, *Ingres Centennial Exhibition* (Cambridge: Fogg Art Museum, Harvard University, 1967), no. 110.

2 Mongan and Naef, *Ingres*, no. 110.

3 Marjorie Benedict Cohn in ibid., p. 245.

Pencil

13¾₁₆ x 10 (33.6 x 25.7)

Inscribed lower right in pencil: *à son ami Simard/Ingres Del./1857*

Inv. no. 1932:130

Elisabeth H. Gates Fund

Provenance: Charles Simart; Prosper Baltard (the sitter's father); Victor Baltard; Wildenstein & Co., New York; purchased, 1932.

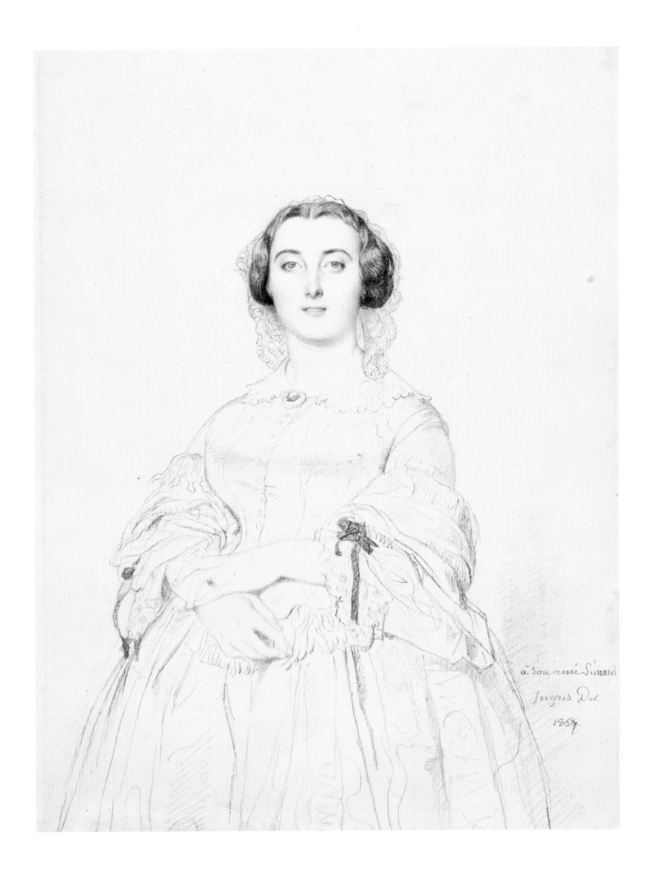

à Son ami Simard
Ingres Del
1854

PAUL CÉZANNE
French, 1839–1906

Sous-bois (White Tree Trunks), c. 1882–84

Watercolors are considered to be among Paul Cézanne's finest works and date from all periods of his oeuvre. The mature watercolors vary widely in execution and appearance, ranging from densely colored compositions to pencil sketches enlivened by deft touches of color. These works are important not only for their innovative and influential approach but also for their relationship to the artist's later oil paintings.

Sous-bois (*White Tree Trunks*) is characteristic of Cézanne's watercolor style of the early to mid-1880s. Like other works of the period, it demonstrates his penchant for linear elements, scattered colors, and large areas of untouched paper.[1] His use of white paper in *Sous-bois* is particularly arresting; pencil and watercolor cover only the upper two-thirds of the paper, leaving a vast expanse of white below. By 1926 the watercolor had been incorrectly matted. Much of the foreground was covered, marring the original effect of the composition; due to the resulting discoloration, the work is seen here in an altered state. That the white foreground is integral to the composition of *Sous-bois* is strongly inferred by the many other watercolors by Cézanne completed during this time on paper of similar dimensions.[2]

Although only a small percentage of the sheet is covered with color—a property that has fueled debate over the finished versus unfinished state of many of Cézanne's watercolors—*Sous-bois* appears to be complete. This is due in part to the artist's celebrated method of carefully balancing each line and patch of color at every stage of the picture's evolution; white paper and pencil shading are critical to the composition, functioning in tandem with touches of color. Pencil, watercolor, and untouched paper coexist in symbiotic partnership to create a completely realized work. **AC**

1 See John Rewald, *Paul Cézanne: The Watercolors, A Catalogue Raisonné* (Boston: Little, Brown & Co., 1983), pp. 27–28.

2 See ibid., nos. 170, 173–75, 177–80, 183a.

Pencil and watercolor
18⅞ x 12 (48 x 30.7)
Not inscribed by the artist
Inv. no. RCA 1941:2
Room of Contemporary Art Fund

Provenance: Paul Cézanne, *fils*, Paris; Bernheim-Jeune, Paris; Montross Gallery, New York; John Quinn, New York, 1916; Mrs. Cornelius Sullivan; Anderson Gallery, New York; Pierre Matisse Gallery, New York, 1937; purchased, 1941.

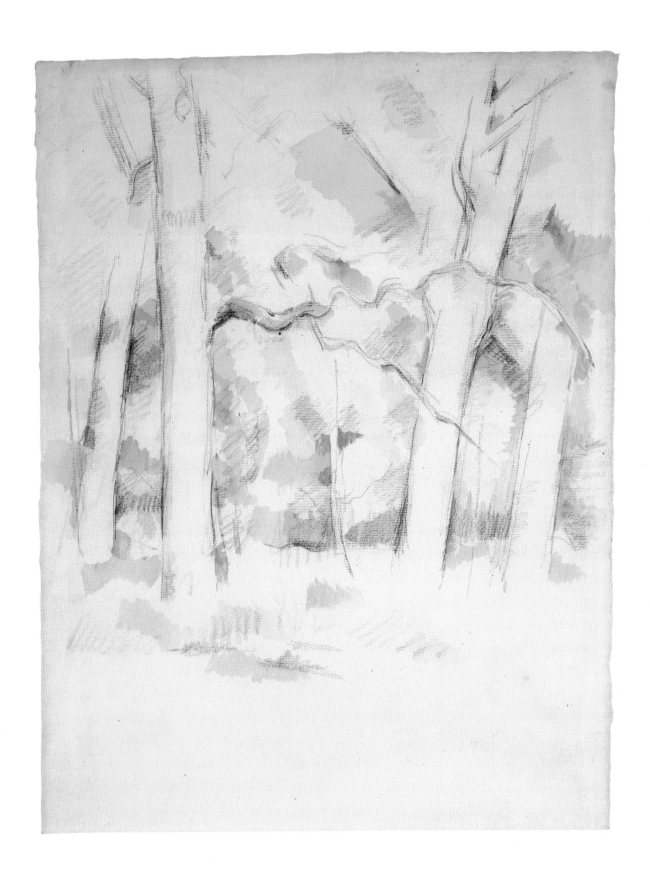

GEORGES PIERRE SEURAT

French, 1859–1891

La Nounou (The Wet Nurse), 1884–85

Between 1884 and 1885 Georges Pierre Seurat produced more than twenty preliminary drawings for his celebrated Neo-Impressionist canvas *Un Dimanche d'été à l'Ile de La Grande Jatte (A Sunday Afternoon on the Island of La Grande Jatte)*. Two figures from that painting are represented in the drawing *La Nounou (The Wet Nurse)*. Without reference to the painting, several forms in the drawing are difficult to identify. The nurse, viewed from the back, is recognizable by her distinctive bonnet and ribbon, but the geometrized tree trunk bending around her bulky form and the dark rectangle defining a man's top hat at lower left have been pruned of all identifying details.

Although *La Nounou* is a preparatory drawing concerned with the refinement of forms and their relationships, it should also be viewed in its own right as an outstanding example of Seurat's innovative and evocative drawing style. No contour lines have been employed. Only the short strokes delineating grass in the lower right betray the point of a crayon. Lacking firm boundaries, the other objects seem to merge with the surrounding space, their soft, immaterial forms and the rich nuances of light and shade owing much to the medium. Pockets of white between the raised tufts of the square-meshed paper enhance the luminous, atmospheric quality of the drawing.

Spatial relationships in *La Nounou* are far from clear. The tree trunk, for example, appears to be at once both beside and in back of the nurse, while the subtle three-dimensional shading of the nurse's cloak is contradicted by the emphatically two-dimensional character of her bonnet and ribbon. Reduced to simple geometric components in a rigorously ordered composition, the figures are faceless, impenetrable forms, devoid of personalizing details. Yet they are monumental even in their anonymity. AC

Conté crayon
9¼ x 12¼ (23.5 x 31.1)
Inscribed on verso upper center in crayon: *G. Seurat/L.*
Inv. no. 1963:3
Bequest of A. Conger Goodyear

Provenance: Félix Fénéon, Paris; John Quinn, New York; A. Conger Goodyear, Buffalo, 1926; bequest, 1963.

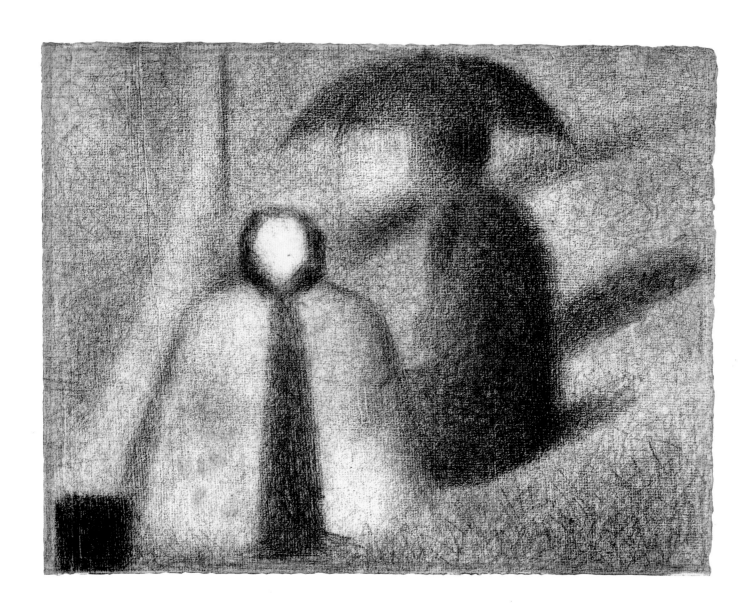

MAURICE PRENDERGAST
American, born Canada, 1858–1924

Along the Boulevard, c. 1894

M aurice Prendergast was the first American artist whose work truly reflected the teachings of French Modernism.[1] Quietly adventurous, his efforts in the medium of watercolor remain outstanding examples, acknowledging the methods of Winslow Homer in the artist's manipulation of the wet page and incorporation of untouched areas of the support as major elements in the composition.

Following years of independent study, Prendergast traveled to Paris in 1891 and for the next three years attended several notable institutions, including the Académie Julian and the Académie Colarossi. His association with the Chat Noir café in Paris, where writers and artists gathered regularly, contributed to his development. British artists, including Aubrey Beardsley and W. Somerset Maugham, frequented the café, as did artist James Wilson Morrice, who, like Prendergast, was of Canadian birth. Liberal minded and familiar with the avant-garde, Morrice, whose painting style reflected the impact of the highly patterned and brightly colored work of Pierre Bonnard and Edouard Vuillard, was a critical influence on Prendergast.[2]

Along the Boulevard is a typical yet exceptional watercolor by Prendergast. Rendered spontaneously with pencil and loosely applied transparent washes, it most likely dates from the artist's last year in Paris. Preferring to work *en plein air*, the artist favored scenes from the gardens of Paris and the parks of Boston and New York, the cities in which he lived. Images of women are frequent, but he rarely depicted individual features, preferring instead to highlight their costumes as abstract forms within his patterned compositions.

Verging on complete abstraction, the free style of this work is related to the artist's experiments with monotypes at this time, while the daring composition is perhaps due to his consideration of the then-new medium of photography. With his manipulation of pigment on a dampened sheet, Prendergast has aptly rendered the "blurred" appearance of subjects in motion, as if caught by the camera. Contributing to this photographic composition is the almost incidental inclusion of the more tightly rendered carriage, barely contained within the distinctly framed composition.

Prendergast received a bronze medal for watercolor at the Pan-American Exposition held in Buffalo in 1901; however, because of its controversial appearance, his work was for the most part unrecognized and his honors were few during his lifetime. He participated in the 1908 exhibition of the Eight at the Macbeth Gallery in New York. The exhibition, organized by Robert Henri, was an infamous statement of rebellion against the academies' strict definition of acceptable style and subject matter. CB

1 See Theodore E. Stebbins, Jr., *American Master Drawings and Watercolors* (New York: Whitney Museum of American Art in association with the Drawing Society, 1977), p. 246.

2 Henry Adams, *American Drawings and Watercolors at the Museum of Art, Carnegie Institute* (Pittsburgh: Museum of Art, Carnegie Institute, 1985), p. 129.

Watercolor with pencil
9⅛ x 12⅛ (23.3 x 31)
Inscribed lower left in ink: *Prendergast*
Inv. no. RCA 1939:3
Room of Contemporary Art Fund

Provenance: C. W. Kraushaar Art Galleries, New York; purchased, 1939.

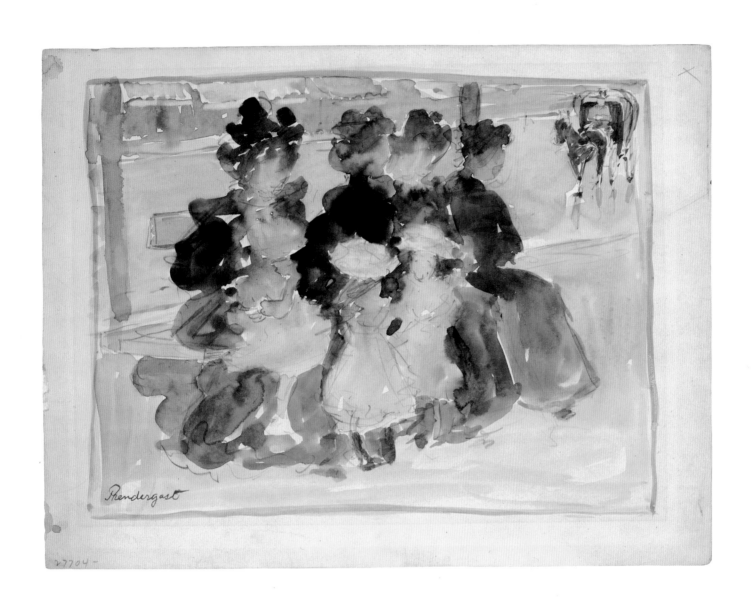

CHILDE HASSAM
American, 1859–1935

Brook Back of New Canaan, Conn., 1902

Childe Hassam is best remembered as a leading practitioner of Impressionist painting in America. Hassam's primary interest, like that of his European counterparts, was the visual realization of atmosphere and light. Even before he became familiar with French Impressionism from travels abroad, Hassam had produced major canvases devoted to contemporary urban scenes, frequently depicting foul weather. Following his return to New York in 1889 after three years of study at the Académie Julian in Paris, Hassam's work reflected the impact of the Impressionists' use of broken brushstrokes and texture to reveal the effects of light.

The medium of pastel was suited to the objectives of the Impressionists by virtue of its nature and the ease with which it could be used *en plein air.* Although the medium was perfectly suited to his style and used often by him, few examples of the artist's work in pastel still exist.[1] One of his earliest subjects in this medium, dating from the period of his studies in Paris, is scenes from horse races.[2] More typical, however, is *Brook Back of New Canaan, Conn.*, a landscape of the artist's favored New England countryside discovered during his summer travels. The sparkling appearance of brilliant sun on active water is attained by the artist's use of repeated dashes in several shades of blue pastel with areas of the support visible. The deep recession and high horizon line are also characteristic of his landscape paintings. This intimate work dates from the period when the artist was at the height of his powers, having received a gold medal only a year earlier at the Pan-American Exposition in Buffalo.[3] **CB**

1 Theodore E. Stebbins, Jr., *American Master Drawings and Watercolors* (New York: Whitney Museum of American Art in association with the Drawing Society, 1977), p. 227.

2 Dianne H. Pilgrim, "The Revival of Pastels in Nineteenth-Century America: The Society of Painters in Pastel," *American Art Journal* 10, no. 2 (Nov. 1978): 62.

3 Donelson F. Hoopes, *Childe Hassam* (New York: Watson-Guptill Publications, 1979), p. 6.

Pastel on tan paperboard
10 x 10⅝ (25.2 x 27.6)
Inscribed lower left in charcoal: *Childe Hassam/02*
Inv. no. 1916:14
Gift of Frederick K. Mixer in memory of his mother, Mary E. Mixer

Provenance: Frederick K. Mixer, Buffalo; presented in memory of his mother, Mary E. Mixer, 1916.

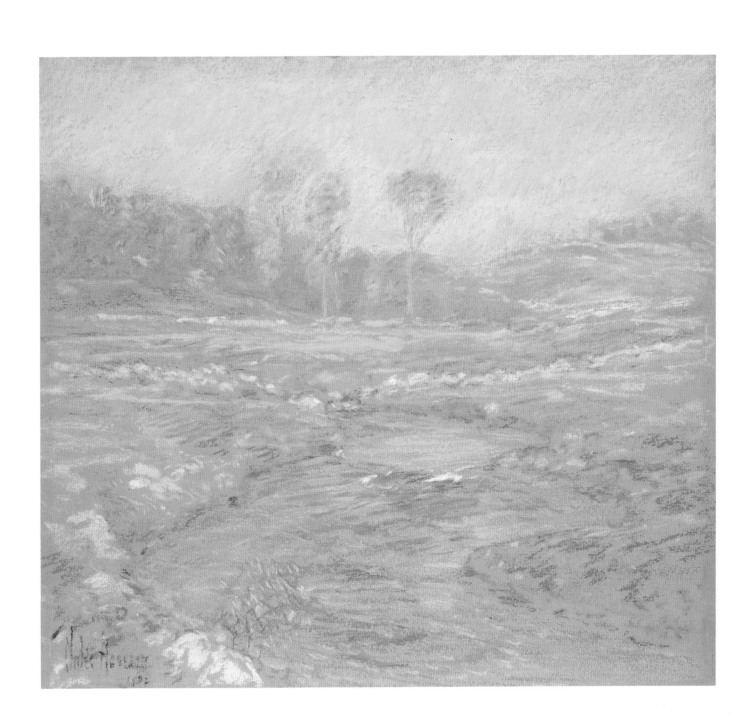

PABLO PICASSO
Spanish, 1881–1973

Famille au souper (Family at Supper), 1903

I n Barcelona in 1903 Pablo Picasso produced a series of drawings and water-colors depicting the life and customs of Spanish peasants. According to Picasso, the works are evocations of his stay at the rural village of Horta de Ebro in 1898.[1] One of the nostalgic scenes, *Famille au souper (Family at Supper)*, depicts a peasant family about to share a simple meal. While the woman stoops to place a bowl on the table, her bent form recalling other figures of the Blue Period,[2] the man grasps a flask of wine. An eloquent glance passes between man and boy, effectively uniting the two.

Despite simple surroundings and meager fare, staples of Picasso's Blue Period paintings, there is no hint of pathos here. Instead, quiet dignity and peace prevail. The simplified contours, linear profiles, and dignified bearing of the figures reflect Picasso's enduring interest in ancient art and evoke a sense of timeless ritual.

The color scheme enhances the mood, with light washes of pinks and mauves providing warmth to counteract the more somber effects of the blues. The colors are carefully balanced with substantial areas of white, and the strong horizontals and verticals of the interior provide a stable framework for the figures.

On the verso is an undated sketch of a hand in a sleeve along with the words *clase de dia*. The style is unlike that of Picasso's early academic drawings, suggesting that he may have painted *Famille au souper* on paper already used by another, perhaps a former fellow student. AC

1 Josep Palau i Fabre, *Picasso en Cataluña* (Barcelona: Ediciones Poligrafa, 1966), p. 116.

2 E.g., *The Soup*, 1902 (Art Gallery of Ontario, Toronto). See also *Sullivan Collection of Modern Artists* (New York: Parke-Bernet Galleries, 1939), no. 36, a watercolor depicting a nearly identical figure.

Watercolor and pen and ink
12⅝ x 17½ (32.2 x 44.3)
Inscribed lower right in ink: *Picasso*
Inv. no. RCA 1941:3
Room of Contemporary Art Fund

Provenance: Gertrude Stein, Paris; Galerie Kate Perls, Paris; Peter Watson, London; French Art Galleries, New York, 1939; purchased, 1941.

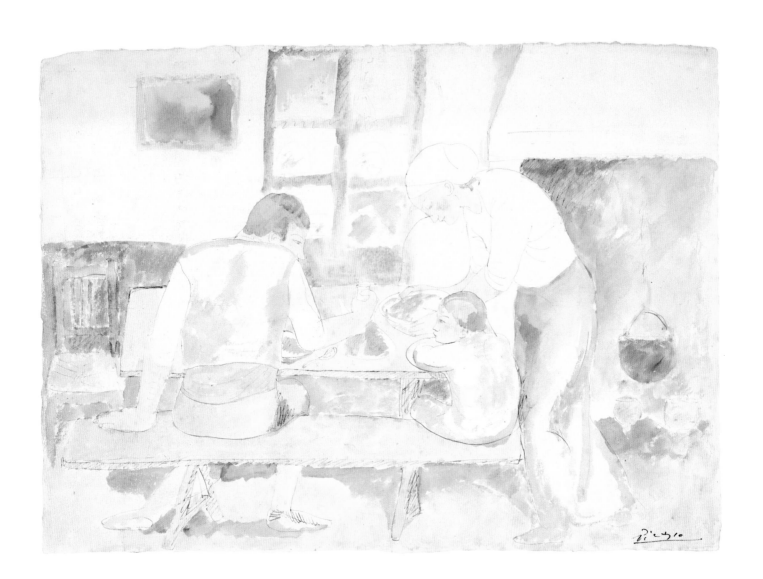

PABLO PICASSO
Spanish, 1881–1973

En scène (On Stage), c. 1901

En scène (On Stage) is one of numerous early works by Pablo Picasso that owe a debt to Henri de Toulouse-Lautrec both in subject matter and in style. Like Lautrec, Picasso was fascinated by the alluring and exotic women who frequented the cafés, music halls, and theaters of Paris at the turn of the century. In this pastel on brown paper, Picasso depicts a Parisian entertainer. A singer or diseuse, one who specializes in recitation, the woman stands on an elevated stage high above the orchestra. She leans forward slightly, her pose and the attentive musician below suggesting a climactic moment.

Picasso's fascination with the depiction of artificial lighting is evident in his dramatic use of color. While the audience is only dimly perceived within a darkened interior, the stage is brightly illuminated, focusing attention on the performer, with her vivid theatrical makeup and brilliant costume. Picasso has used the luminous qualities of the medium to splendid effect in this evocation of the lurid hues of Parisian nightlife.

Several related drawings in the Museo Picasso in Barcelona appear to feature the same woman,[1] whose striking red hair and slender form suggest a reference to the singer Yvette Guilbert, who was a favorite of Lautrec. The death of Toulouse-Lautrec in 1901 may, in fact, have inspired Picasso's drawings of the entertainer.[2] None of Picasso's works, however, includes the long black gloves that were Guilbert's trademark, precluding a positive identification. The style of En scène and the related works would support a dating of either 1900 or 1901; the consistent use of the signature *Picasso*, instead of the variations common in 1900, makes a date of 1901 more likely. AC

1 Museo Picasso, Barcelona, 4.777, 4.270, and 4.276.

2 Josep Palau i Fabre, *Picasso: The Early Years, 1881–1907* (New York: Rizzoli International Publications, 1981), p. 261.

Pastel on brown paper prepared with gray ground
19½ x 13⅛ (49.5 x 33.3)
Inscribed lower left in pastel: *Picasso*
Inv. no. 1966:9.16
Bequest of A. Conger Goodyear

Provenance: Sagot, Paris; A. Conger Goodyear, Buffalo, 1923; bequest, 1966.

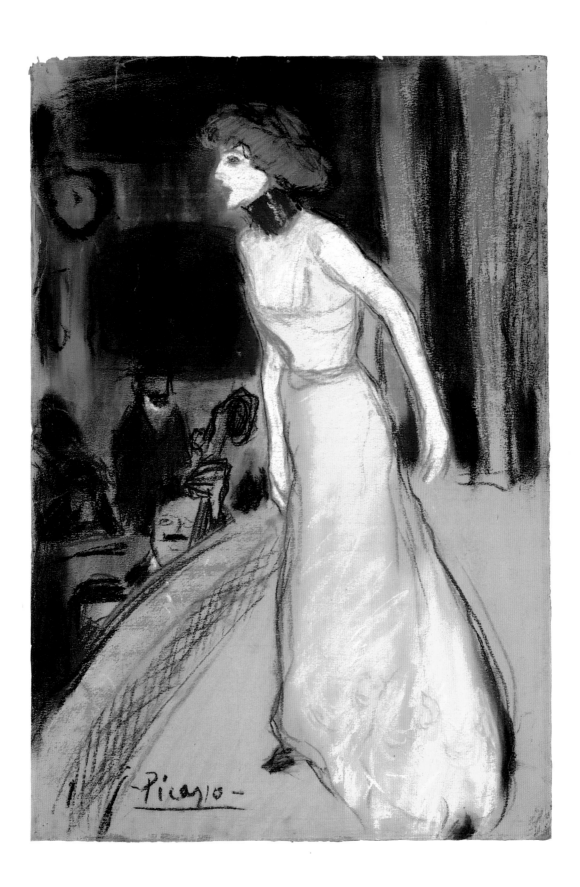

AMEDEO MODIGLIANI
Italian, 1884–1920

Deux femmes (Two Women), 1908

Barely recognizable as a Modigliani, *Deux femmes (Two Women)* is one of the relatively few extant works traceable to the artist's early years in Paris. An Italian by birth, Amedeo Modigliani arrived in Paris in 1906, where he led a legendary Bohemian life marred by drugs, alcohol, and tuberculosis until his death in January 1920 at the age of thirty-five. The paintings for which he is most famous date from the last five years of his life, paintings in which the artist realized more fully his distinctive style.

Deux femmes is reminiscent of Pablo Picasso's early Parisian works of 1900–1901, a similarity that may be due to the influence of Toulouse-Lautrec on both young artists.[1] Unlike Modigliani's other works, which nearly always feature a single head or figure, this watercolor depicts a carefully arranged grouping of figures in both foreground and background. *Deux femmes* is formative in character, revealing the artist's superb skill as a draftsman. Moreover, the work contains hints of Modigliani's mature style, particularly in the long, elegant lines and in the spare definition of space.

Deux femmes is particularly close to a watercolor in the Museum of Fine Arts, Boston, that features the same two women seated alone, wearing the same costumes.[2] The dark-haired woman is probably Maud Abrantès, a friend of Modigliani who appears in other works of the period.[3] The woman at the left, despite her blonde hair, also resembles several depictions of Abrantès, raising the possibility that Modigliani modeled both figures after the same woman. AC

[1] While the influence of Picasso is problematic, evidence exists that Modigliani was aware of the similarity of his work to that of his famous contemporary; see Jeanne Modigliani, *Modigliani: Man and Myth* (New York: Orion Press, 1958), p. 40.

[2] *Deux Femmes et trois études de têtes (Two Women and Three Studies of Heads)*, c. 1908, inv. no. 61.1030.

[3] She is also known as Moder Branteska; see Arthur Pfannstiel, *L'Art et la vie: Modigliani* (Paris: Editions Marcel Seheur, 1929), pp. 2, 35.

Watercolor and pencil on blue laid paper [faded]
15 x 12 (38 x 31)
Not inscribed
Inv. no. 1943:4
Gift of A. Conger Goodyear

Provenance: Dr. Paul Alexandre, Paris; Paul Guillaume, Paris; A. Conger Goodyear, New York, 1930; presented, 1943.

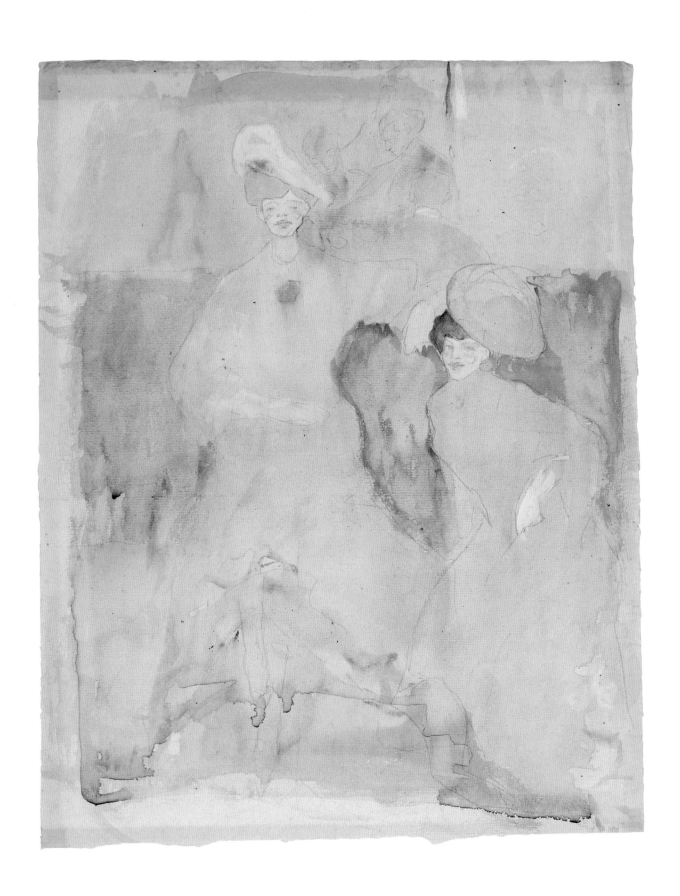

ELIE NADELMAN
American, born Poland, 1882–1946

Head of a Woman, c. 1907

Finished pen-and-ink drawings comprise the major part of Elie Nadelman's oeuvre in Paris, where he lived for several years and where he had in 1909 the first exhibition of his controversial works. So sensational was the critical response to the artist's exploration of abstract form and volume in his drawings and sculpture that Henri Matisse is reported to have placed a sign in his studio to discourage any discussion of the artist.[1] In the first decades of the twentieth century Nadelman's influence was far reaching and his visual concept aided in the imminent realization of Cubism, although he never subscribed to the final and complete dissolution of form. Writing on his art for an exhibition at the Little Galleries of the Photo-Secession in New York, known as 291, Nadelman explained:

I employ no other line than the curve, which possesses freshness and force. I compose these curves so as to bring them in accord or in opposition to one another. In that way I obtain the life of form, i.e. harmony.[2]

The use of sweeping curves and of pen and ink as his medium encouraged the appearance of delicacy and gracefulness in his drawings, as seen in *Head of a Woman*, a typical subject. Bands of cross-hatching accent the model's flowing hair and add volume to the simple linear definition of her features.

The characteristic sleekness and fluidity of his drawings are also visible in Nadelman's sculpture. After he emigrated to America in 1914, Nadelman no longer concentrated on drawing, frequently sketching only as a preliminary step in the evolution of his sculpture. **CB**

[1] Lincoln Kirstein, *The Sculpture of Elie Nadelman* (New York: Museum of Modern Art, 1948), p. 18.

[2] Elie Nadelman, "Photo-Secession Notes: The Photo-Secession Gallery," *Camera Work*, no. 32 (Oct. 1910): 41.

Pen and ink and pencil on brown paper
21 x 12⅝ (53.3 x 32.1)
Inscribed lower left in ink: *A tres honoré Monsieur/E. J. Lunez/ cordialement/Eli Nadelman*
Inv. no. 1953:6
Charles W. Goodyear Fund

Provenance: Peter H. Deitsch, New York; purchased, 1953.

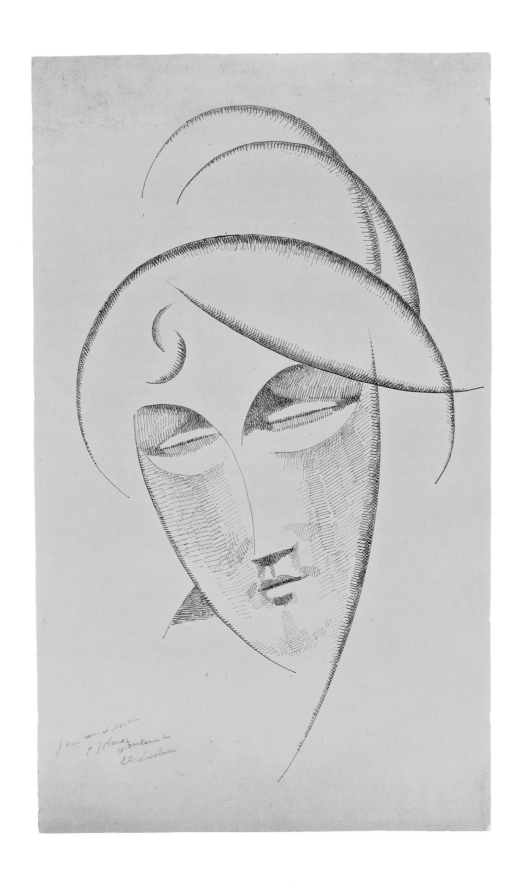

SUZANNE VALADON

French, 1865–1938

La Mère et l'enfant à toilette (Mother and Child at Bath), 1908

Upon first viewing the drawings of Suzanne Valadon in 1894, the then-elderly Edgar Degas proclaimed her "a natural talent." In Montmartre, where she lived a Bohemian life, Valadon was best known as a model who had been singled out for her striking features by, among others, Pierre Puvis de Chavannes, Auguste Renoir, and her neighbor Henri de Toulouse-Lautrec. Her association with these revolutionary artists revived her interest in drawing, which she had discovered as a child growing up on the streets of Montmartre. It was, however, with the encouragement of Lautrec and with the guidance of the master draftsman Degas that Valadon committed herself to developing her talent. As one of few confidants of the reclusive Degas, her familiarity with this artist's work was an inspiration to her own.

Everyday scenes from Valadon's immediate environment were her favored subjects. She frequently depicted the various stages of a woman's toilette, as did her mentor. The year 1908, in which this typical charcoal drawing was made, was one of transition in the artist's personal and artistic life; the following year is recognized as the beginning of her mature style and was also the year in which she left her comfortable life as the wife of a wealthy banker to live with André Utter, a painter several years her junior whom she had met through her son, the artist Maurice Utrillo.

With bold lines confidently drawn, Valadon has here depicted an instant in a familiar routine without creating an atmosphere laden with emotional overtones or texture, as did Degas and Lautrec in their works of similar subjects. The figures in this composition, characteristic of Valadon's drawings and etchings, are defined only by rich, dark outlines, which heighten their appearance as simple, naked creatures. Surprisingly, the harsh light resulting from the severe contrasts and absence of shading only emphasizes the mundane reality of Valadon's subject; her expression is not that of an observer but of a knowing relation. Despite the lack of detail, Valadon has offered a tender view through the almost playful pose of the young woman on the left, whose head is tipped to one side as she crouches at the edge of the basin. At the same time, a feeling of vulnerability is communicated by the placement of this intimate routine near an open door. **CB**

Charcoal
12⅝ x 12⅛ (32.3 x 30.8)
Inscribed lower right in charcoal· *Suzanne Valadon/1908*
Inv. no. 1970:2.63
Gift of ACG Trust

Provenance: From the artist to Galerie Zak, Paris; A. Conger Goodyear, New York, 1929; bequest, 1970.

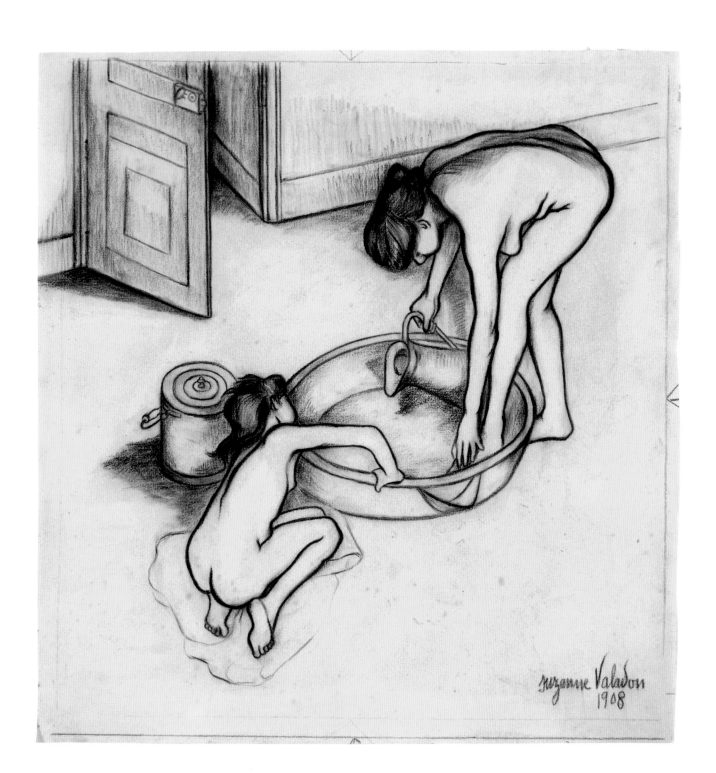

Suzanne Valadon
1908

ODILON REDON
French, 1840–1916

Vase de fleurs (Vase of Flowers), c. 1912–14

Long known as a master of images in black and white, Odilon Redon turned to pastels in the early 1890s, reveling in their brilliancy.[1] Once committed to color, Redon frequently turned to flowers for inspiration. During the last fifteen years of his life, the innumerable bouquets that graced his pastels and oils came from his own property. In 1910 his wife inherited a house in the country not far from Paris that became their summer residence; there she tended and arranged the flowers that brought Redon such obvious pleasure.[2]

Depicting a meticulously observed arrangement of lilacs and anemones from the Redons's own garden, *Vase de fleurs (Vase of Flowers)* is nevertheless no ordinary naturalistic still life. A solitary image isolated against a brilliant but undefined background, the bouquet assumes a cryptic quality, encouraging speculation about mystical allusions and Symbolist meditations on mortality. The sumptuous colors and textures of the fragile petals belie their inevitable decay.

Even in so potentially prosaic a subject, Redon strove for a delicate balance between imagination and direct observation. He sought to achieve an effect that he himself ascribed to Jean-Baptiste-Camille Corot, whom he greatly admired:

If, for the expression of his dreams, [Corot] . . . intentionally leaves vague jumbles almost obliterated in semi-obscurity, he immediately places next to them a detail superbly firm and well observed. This proves clearly that the artist knows much; his dream is supported by a seen reality.[3]

Using delicately smudged colors and indefinite boundaries, Redon allows the forms to merge into the richly textured background. Soft, velvety light seems to emanate from the flowers themselves, supplementing the exterior light and suffusing the image with a magical glow. AC

1 In a letter to E. Picard in 1894, Redon wrote: "With pastel I have recovered the hope of giving my dreams greater plasticity, if possible. Colors contain a joy which relaxes me" (cited in John Rewald, *Odilon Redon/Gustave Moreau/Rodolphe Bresdin* [New York: Museum of Modern Art, 1961], p. 39).

2 Ibid., p. 44. For a discussion of the dating of *Vase de fleurs*, see Steven A. Nash, in Buffalo Fine Arts Academy, *Albright-Knox Art Gallery: Painting and Sculpture from Antiquity to 1942* (New York: Rizzoli International Publications in association with Albright-Knox Art Gallery, 1979), p. 440.

3 Odilon Redon, "Salon de 1868, I—Le Paysage: MM. Chintreuil, Corot, et Daubigny," *La Gironde*, 19 May 1868; cited in Rewald, *Redon*, p. 18.

Pastel on red paper [faded]
28⅝ x 18⅟₁₆ (72.8 x 45.9)
Inscribed lower left in charcoal: *ODILON REDON*
Inv. no. RCA 1940:7
Room of Contemporary Art Fund

Provenance: Ari Redon, Paris; Reid and Lefevre Gallery, London, by 1938; Bignou Gallery, New York; purchased, 1940.

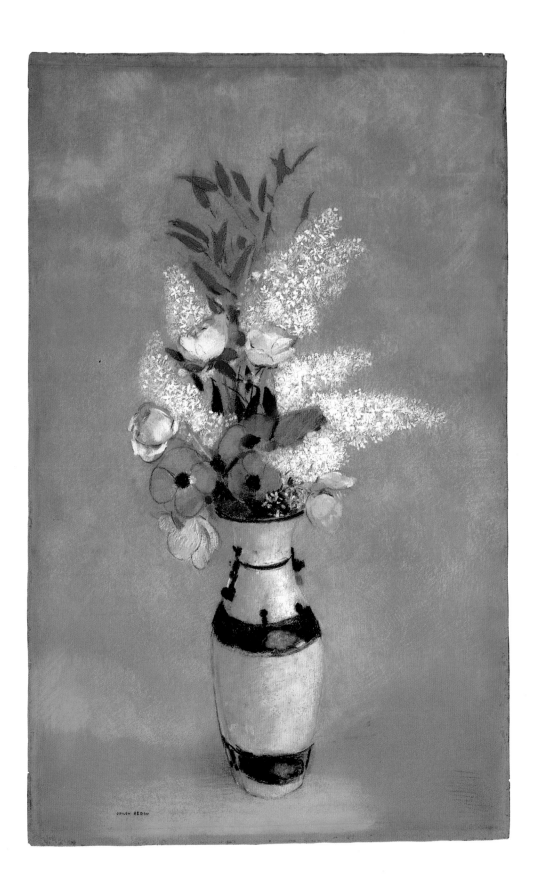

GWEN JOHN
British, 1876–1939

Bust of a Woman, c. 1910

Despite confidence in her work and its future significance, Gwen John exhibited infrequently and led a life of extreme privacy, quite unlike her better-known, flamboyant brother, the artist Augustus John.[1] Drawing was an integral part of life for both during their youth in Wales, and both attended the Slade School of Fine Art in London, earning recognition for figurative compositions.

Gwen John moved in 1903 to Paris, where she spent most of her life in relative seclusion creating works expressive of her singular vision of her friends and environment. At first, in need of income, she modeled for artists, including Auguste Rodin, whom she met in 1904 and whose mistress she became. Rodin's loose, spontaneous style of drawing greatly influenced John's mature work, as is evident in *Bust of a Woman*, a sketch of her friend Chloe Boughton-Leigh made about 1910.

With lines that appear at once fragile and effortless, the artist has captured her subject's distinctive features and delicate nature in an expression of intimacy that pervades her paintings and drawings. The use of a single figure was typical of her work. Her palette was primarily subdued and had a remarkable sense of tone, according to James McNeill Whistler, with whom she briefly studied at his Académie Carmen, Paris, in 1898.[2] This sensitivity to color and restricted palette were, perhaps, results of her studies with Whistler and are evident even in this simple sketch, in which she has used only graphite and gray wash on brown kraft paper.

This work is one of a group of sketches related to a 1910 oil painting of Miss Boughton-Leigh,[3] which was the second oil painting of the subject completed by the artist. This sketch was among the first works by Gwen John purchased by the American collector of the avant-garde John Quinn, who became her greatest supporter, financially and spiritually, until his death in 1924. **CB**

[1] Betsy G. Fryberger, *Gwen John* (Stanford, Calif.: Stanford University Museum of Art, 1982), p. 6.

[2] Cecily Langdale, *Gwen John* (New York: Davis & Long Company, 1975), p. 9.

[3] Cecily Langdale, *Gwen John: An Intimate Vision* (London: Barbican Center and Phaidon Press, 1985), p. 89. The painting is in the collection of Leeds City Art Galleries, England.

Pencil and wash on kraft paper
9¾ x 7¼ (24.6 x 18.4)
Not inscribed
Inv. no. 1953:7.19
Gift of A. Conger Goodyear

Provenance: From the artist to John Quinn, New York, 1914; A. Conger Goodyear, Buffalo, 1927; presented, 1953.

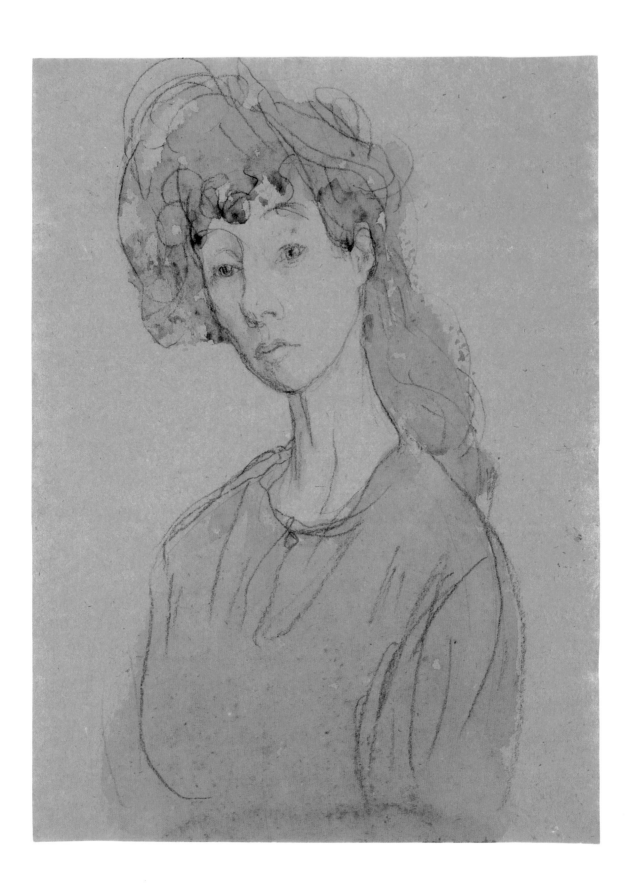

GEORGES ROUAULT
French, 1871–1958

Femme au chapeau (Woman in a Bonnet), 1907

The weary, aging woman portrayed in *Femme au chapeau (Woman in a Bonnet)* belongs to a vast repertoire of wretched figures in Georges Rouault's paintings and drawings from 1903 to 1914. Prostitutes, clowns, judges, financiers, and entertainers were all subjects for Rouault's caustic expressions of outrage at the moral depravity of bourgeois French society. Frequently executed on paper in various combinations of watercolor with other media, these works are notable for their expressive intensity.

A favorite theme of the period concerns the tragic plight and physical deterioration of prostitutes and other marginal figures in a neglectful, vice-ridden society. Horrifying his contemporaries, Rouault was unsparing in his depictions of the repellent flesh and coarse vulgarity of the streetwalkers of Montmartre who served as his models.[1] Although fully clothed and disassociated from a specific milieu, the protagonist of *Femme au chapeau* has certain affinities with Rouault's nude prostitutes. Like them she has aged ungracefully, her beefy face and bulky form bearing witness to the ravages of time. Her hunched shoulders, graceless pose, and grim face eloquently convey enormous weariness of both body and spirit.

Rouault is not unsympathetic to the woman's plight; his acerbic criticism is directed not at her but at the society that produced her. The dark, slashing strokes and vivid highlights that so furiously define the woman's image reflect the religious fervor of Rouault's resolve. Typically, he makes no effort to soften his message by making the figure less brutish or by imparting a smooth academic finish to his work. The frenetic energy of his style is central to the theme and to the relentless power of the image. AC

1 See John Russell, *Rouault* (London: Arts Council of Great Britain in association with Royal Scottish Academy, 1966), pp. 9, 26.

Watercolor and pencil
7¹⁵⁄₁₆ x 5⅜ (20 x 13.7)
Inscribed lower right in ink: *Georges Rouault 1907*
Inv. no. 1954:1.6
Gift of A. Conger Goodyear

Provenance: Michel Galerie, Paris; A. Conger Goodyear, Buffalo, 1927; presented, 1954.

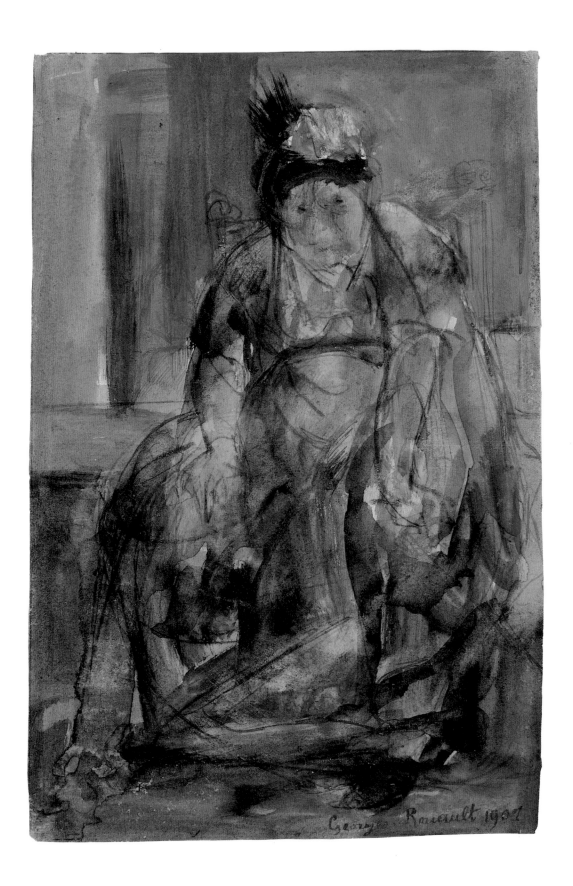

Georges Rouault 1902

LOVIS CORINTH
German, 1858–1925

Die Versuchung des Heiligen Antonius (The Temptation of Saint Anthony), c. 1894

Feeling a greater affinity for the work of seventeenth-century Dutch masters—especially Rembrandt van Rijn and Frans Hals—than for that of his contemporaries, Lovis Corinth developed an intensely expressive style that was an influence on the development of German Expressionism. His work reflects an allegiance not to any one group or medium, but instead to an acute sensitivity, which in his late work sometimes borders on an obsession with decay and death.

Achieving his mature style in fin-de-siècle Germany, Corinth depicted the typical literary, mythological, and religious themes of the time.[1] Although symbolic settings and attributes identify these themes and their characters, Corinth's portrayals were always based in the real world. Human frailty and vulnerability were emphasized in his depictions in a variety of media. Corinth's affinity for the medium of oil did not inhibit his brilliant mastery of other graphic techniques, and his interest in etching resulted, in fact, from a desire to improve his draftsmanship.[2]

The Temptation of Saint Anthony was an appropriate theme in an era when excess and decadence prevailed. In Corinth's pencil drawing, earthly desires are represented by brazen figures, both nude and grotesque. Corinth exceeds a simple conveyance of temptation by placing a voluptuous female, arms outstretched, in the form of the cross—a willing, if vulnerable, barrier between Saint Anthony and the symbol of his religious commitment. Saint Anthony is more clearly defined, and thus more clearly human, than the sketchy apparitions placed before him. The verso of this sketch is covered with red chalk, evidence of the transfer of the image for one of ten etchings completed in 1894 for the series entitled "Tragikomödien."[3] As was his habit, Corinth also made a painted version of this subject in 1897.[4] **CB**

1 Hilton Kramer, *Lovis Corinth* (New York: Foundation for Modern Art, 1964), p. 15.

2 Artist's statement in *Lovis Corinth 1858–1925* (Chicago: Allan Frumkin Gallery, 1958), n.p.

3 Letter from Thomas Corinth, the artist's son, to Gordon M. Smith, 8 Mar. 1961, in the Gallery files.

4 *Die Versuchung des Heiligen Antonius (The Temptation of Saint Anthony)*, 1897, oil on canvas, 34⅛ x 42⅛ inches, Bayerische Staatsgemäldesammlungen, Munich.

Pencil

16 x 19⅛ (40.5 x 48.5)

Stamped on verso lower center: *Atelier—Lovis Corinth*

Inv. no. 1960:5.2

Gift of Thomas Corinth

Provenance: Thomas Corinth, New York; presented, 1960.

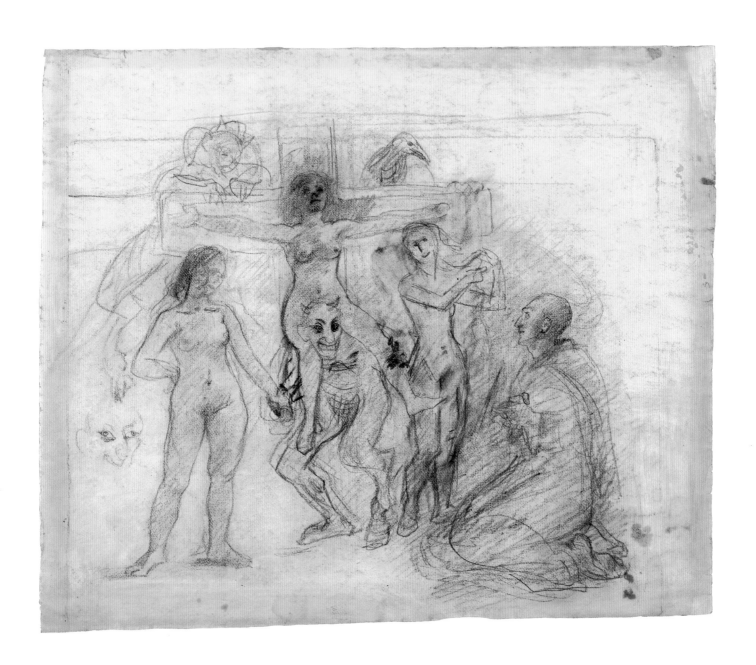

HENRI GAUDIER-BRZESKA
French, 1891–1915

Reclining Nude, 1913

Before his death on the battlefield at the age of twenty-three, Henri Gaudier-Brzeska was regarded in England as a gifted young artist. His reputation declined following his death, and not until decades later were his achievements again widely recognized. Born Henri Gaudier, the young French sculptor moved to London in the winter of 1910–11. He was accompanied by the Polish writer Sophie Brzeska whom he had met in Paris and soon affixed her surname to his own. During the next few years Gaudier-Brzeska produced quantities of drawings and a substantial number of sculptures, attracting the interest and support of prominent literary and artistic figures. By 1914 he had joined the fledgling English movement known as Vorticism, which was essentially a celebration of abstraction, modern civilization, and machine forms. He produced his own "Vortex" manifesto in the same year.

Although Gaudier-Brzeska considered himself primarily a sculptor, his drawings have been justly admired for their quality and variety. *Reclining Nude* probably derives from one of the life-drawing classes the artist attended in Chelsea. The fluid line reflects the speed and ease with which he worked. He wrote of his classmates who labored over two or three drawings in as many hours:

[They] think me mad because I work without stopping—especially while the model is resting, because that is much more interesting than the poses. I do from 150 to 200 drawings each time, and that intrigues them no end.[1]

With masterly control, Gaudier-Brzeska rapidly sketched the model, the contour lines alone creating the illusion of a figure in the round. Despite the swift execution, the artist was not oblivious to the individuality of the model; the same fluid line that defines her body also captures her distinctive features. The beauty and sensitivity of this drawing—reflected even in the placement of the figure on the paper—are characteristic of Gaudier-Brzeska's finest works. AC

1 Letter to Sophie Brzeska, 17 Nov. 1912; cited in H. S. Ede, *Savage Messiah* (New York: Alfred A. Knopf, 1931), p. 188.

Pen and ink
10 x 15⅛ (25.4 x 38.4)
Inscribed lower left in ink: *Henri Gaudier Brzeska 13*
Inv. no. 1970:2.27
Gift of A. Conger Goodyear Trust

Provenance: Ede Tate Gallery, London; A. Conger Goodyear, New York, 1929; bequest, 1970.

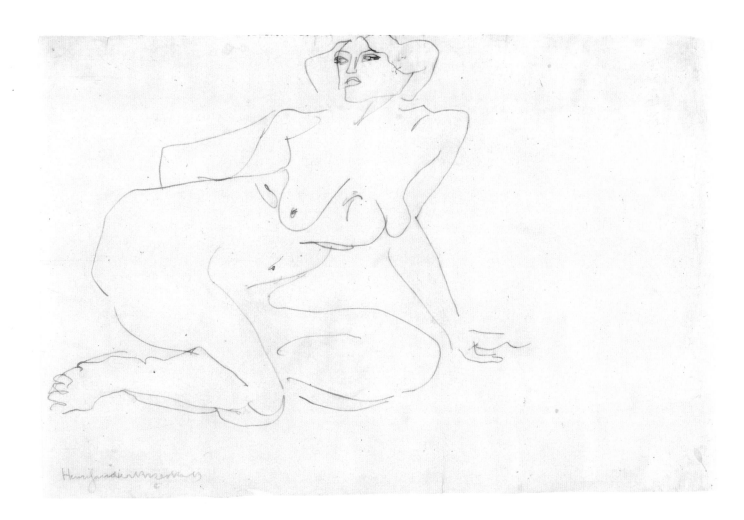

FRANTISEK KUPKA
French, born Czechoslovakia, 1871–1957

Study for "Autour d'un point," c. 1912

As one of the first artists to achieve total abstraction in his paintings, František Kupka earned a place in the forefront of the Parisian avant-garde. Before going to Paris in 1896, he studied in Prague and in Vienna, where he was exposed to spiritism, folk art, Theosophy, Nazarene art, and nineteenth-century color theories. All had a lasting influence on his art. Striving to create linear and color harmonies that would be analogous to music, Kupka sought inspiration in images and forms that reflected natural or cosmic laws, movements, and rhythms.

The Gallery's untitled watercolor appears to be one of the earliest studies for Kupka's painting *Autour d'un point (Around a Point)*, 1925–30 (Musée National d'Art Moderne, Paris). More linear and less suggestive of organic forms than related studies, most of which have been dated to 1920–30,[1] the work recalls pictorial themes found in earlier series, such as the "Disques de Newton" ("Disks of Newton") and "Amphora, Fugue à deux couleurs" ("Amphora, Fugue in Two Colors"). That it belongs to the "Autour d'un point" series is indicated by the elliptical shapes formed by overlapping circles, which in later studies become petal or leaf forms.

Like so many of the artist's works, this study is based on a theme of cosmic dynamism and celestial motion. Elliptical distortions and an interplay of prismatic colors radiate from a central core and suggest rotation in space. Kupka's nontraditional use of color results in planes that appear to shift in depth; for example, the luminous yellow sphere in the background appears to move forward. Radiating lines push beyond the frame while unpainted areas suggesting white light combine with areas of blue to create an image of intense solar illumination surrounded by infinite space. AC

1 For dates of related studies, see Margit Rowell, *František Kupka 1871–1957: A Retrospective* (New York: Solomon R. Guggenheim Museum, 1975), pp. 81, 268.

Watercolor, gouache, and pencil on watercolor paper
9 x 9¹⁄₁₆ (22.9 x 23)
Inscribed lower left in pencil: *Kupka*
Inv. no. 1973:5
Edmund Hayes Fund

Provenance: Robert Elkon Gallery, New York; purchased, 1973.

MORGAN RUSSELL

American, 1886–1953

Study for Synchromy in Orange: To Form, c. 1913–14

Upon his arrival in Paris in 1909, Morgan Russell focused his attention on the study of sculpture. Within a few years, however, sculpture became secondary to the paintings in which he developed his theory of Synchromism, conceived in 1912. Literally meaning "with color," Synchromism fulfilled the challenge set by Russell and fellow expatriate Stanton Macdonald-Wright to interpret sculptural form in two dimensions through color properties; it became the first painting movement with American origins to rival modern European trends.[1] Central to Russell was a consideration of the planar abstractions of Paul Cézanne's work and the vibrant palette of the Fauves—especially Henri Matisse. While acknowledging the work of Sonia and Robert Delaunay, Russell and Macdonald-Wright were profoundly influenced by their instructor Ernest Percyval Tudor-Hart, a little-known theorist who developed a mathematical system of correspondences between color and music.[2]

By 1913 Russell and Macdonald-Wright had exhibited their first Synchromist canvases in Munich and Paris, and by the spring of the following year Russell had completed his major Synchromist work *Synchromy in Orange: To Form*, originally titled *Synchromie en orange: La Création de l'homme conçue le résultat d'une force génératrice naturelle (Synchromy in Orange: The Creation of Man Conceived as the Result of a Natural Generating Force),*[3] also in the collection of the Albright-Knox Art Gallery. In the monumental painting, which exceeds eleven by ten feet, and in this lively sketch, Russell makes explicit reference to the *Dying Slave*, c. 1513, a sculpture by Michelangelo that he had studied at the Louvre.

Realistic studies of the sculpture evolved into studies of the interlocking abstract wedges that are the primary visual element of the painting. This drawing was one of several the artist made before completing the canvas. The dense passage on the right nears the final painting in proportion and composition. The sweeping contrapposto of the sculpture is translated into abstraction. Although understood to be the essence of the figurative sculpture by Michelangelo, the *S* curve at left is composed of two interlocking wedges that are not obvious in the painting. *Beaucoup de teints blancs* (a lot of white colors) is inscribed faintly in the upper left, perhaps encouraging a reading of this study as a page of ideas and directions for the final painting. CB

1 Gail Levin, *Synchromism and American Color Abstraction 1910–1925* (New York: George Braziller in association with Whitney Museum of American Art, 1978), p. 9.

2 Ibid., p. 14.

3 Ibid., p. 25.

Pencil

9½ x 12¼ (24.2 x 31)

Inscribed upper left in pencil: *Beaucoup de/teints blancs*

Inv. no. 1978:17

George Cary Fund

Provenance: From the artist to Louis Sol, Montrouge, France; Benjamin F. Garber, St. Martin, West Indies, 1965; purchased, 1978.

FELIX DEL MARLE
French, 1889–1952

Chemin de fer (Railway), 1914

I n 1913 Félix del Marle created a furor with the publication of his vitriolic "Manifesto against Montmartre," securing his place as a prominent French proponent of Futurism. Like his Italian colleagues, del Marle rejoiced in twentieth-century technology. A celebration of travel by rail, *Chemin de fer (Railway)* reflects this enthusiasm; the entire composition expresses the speed and dynamism of modern transportation. Rails converge in the distance, while a succession of curves, wedge-shaped diagonals, and cometlike forms give direction to the movement and seem to hurtle the viewer down the track. Streaks of fiery orange delineate the rails, suggesting the recent passage of a speeding train. Fractured lines and planes complete the illusion, expressing velocity, side-to-side movement, and a bewildering blur of fragmented objects.

The drawing relies heavily on Cubist techniques: angular forms, interpenetrating planes, multiple viewpoints, lettering, and the fusion of forms and space. Their use, however, is clearly Futurist in purpose. The open contours, semitransparent planes, and shifting points of view all contribute to a sense of simultaneity. Futurist, too, are the fractured cones of brilliant white that emanate from electric bulbs, revealing a characteristic fascination with artificial lighting.

The words that are part of the drawing serve several purposes. The sign designating the town Creil suggests the woman's destination, while the German sign with its safety warning suggests both foreign travel and the dangers inherent in modern, high-speed transportation. The newspaper carries a more personal association, for del Marle's art, his Futurist manifesto, and the controversy surrounding them were all featured in the pages of *Comoedia*.[1] AC

1 Gerald Silk, "Félix del Marle: French Futurist," *Arts Magazine* 57, no. 3 (Nov. 1982): 97.

Paint on blue paperboard [faded]
19¹¹⁄₁₆ x 13 (50 x 33)
Inscribed lower right in ink: *A.F.M.D./1914*
Inv. no. 1982:20
James S. Ely and Room of Contemporary Art Funds, by exchange

Provenance: Michael Hasenclever, Munich; Carus Gallery,
New York, 1981; purchased, 1982.

KASIMIR MALEVICH
Russian, 1878–1935

Suprematist Composition: Expressing the Feeling of Fading Away, 1916–17

In a celebrated treatise on art, Kasimir Malevich defined his theory of Suprematism as "the supremacy of pure feeling in creative art."[1] His small drawing *Suprematist Composition: Expressing the Feeling of Fading Away* admirably fulfills the artist's criteria for a Suprematist work by employing nonobjective forms to express a specific sensation or feeling. It consists of a diagonal beam intersected by three curving lines, suggesting three-dimensional shapes floating freely in space.[2] The forms appear both to fade away and to ascend, the diagonal line—favored by Malevich for its dynamic qualities—giving direction to the movement.

The ethereal quality of the drawing is not accidental. References to the spiritual, the universal, and the infinite abound in Malevich's writings, and mystical allusions to space and the forces of the universe are central to his work. In *Suprematist Composition: Expressing the Feeling of Fading Away*, Malevich expertly employs the expressive possibilities of his materials to evoke cosmic allusions. The transparent, tissuelike paper and the delicate gray tones of the artist's pencil contribute to a sensation of infinite space and freedom from the forces of gravity, while soft, subtle shading and freely drawn lines reveal the sensitive touch of the artist and reaffirm the human element.

Multiple meanings, ranging from the political to the anthropomorphic, have been suggested for this drawing. Most intriguing is the suggestion that the curves represent a potential sphere rotating about the diagonal axis in a kind of cosmic metaphor for the movement of the planets. In this interpretation even the angle of the diagonal is significant; it duplicates the angle of the earth's axis to become a symbol of the universalism of Suprematism.[3] AC

1 Kasimir Malevich, *The Non-Objective World*, trans. by Howard Dearstyne (Chicago: Theobald, 1959), p. 69.

2 Several works of 1916–17 are closely related, including an oil painting of the same title (Stedelijk Museum, Amsterdam).

3 Alan C. Birnholz, "Forms, Angles, and Corners: On Meaning in Russian Avant-Garde Art," *Arts Magazine* 51, no. 6 (Feb. 1977): 103–5.

Pencil on tracing paper
6¹⁄₁₆ x 4³⁄₁₆ (15.4 x 10.7)
Not inscribed
Inv. no. 1968:6
Gift of Marlborough-Gerson Gallery

Provenance: Marlborough-Gerson Gallery, New York; presented, 1968.

FRANZ MARC
German, 1880–1916

Märchentier (Fairy Animal), 1913

Convinced of the superiority of animals over man, the German Expressionist Franz Marc evolved a style that conformed to his pantheistic view of the world. Characterized by a use of non-naturalistic color, a rhythmic repetition of line and form, and a passion for animal motifs, Marc's mature works of 1911 depict a magical world in which animals live in perfect harmony with nature. As Europe drifted toward the war that would claim Marc's life, however, the artist's lyrical paintings of animal innocence soon yielded to harsher images of menacing beasts and fiery destruction.

An ominous creature, the hybrid elephant-bird of *Märchentier (Fairy Animal)* reflects Marc's predilection in 1913 for themes of chaos and violence. As in earlier works, animals and nature appear to coexist, but gone is the serene harmony of gently rolling hills and elegantly curved horses' backs. Instead, *Märchentier* churns with wild, swirling pigments, creating an abstract, chimerical milieu appropriate to the fanciful beast. Massive waves of brilliant color well up on the right, seeming to propel the beast forward. While many of Marc's works of 1912 and 1913 display angular, crystalline forms that reveal the artist's debt to Robert Delaunay and to the structural techniques of Cubism and Futurism, *Märchentier* relies on curvilinear rhythms and areas of transparent color to effect the symbolic fusion of the creature with its environment. No placid, innocent victim, the animal charges forth with a malevolent eye, its aggressive stance and the frenetic world about it reflecting the anguish and terror that pervade so many of Marc's paintings of this period. AC

Gouache and watercolor
16⅛ x 18¼ (41.1 x 46.3)
Inscribed lower right in tempera: M.
Inv. no. RCA 1941:8
Room of Contemporary Art Fund

Provenance: Nierendorf Gallery, New York; purchased, 1941.

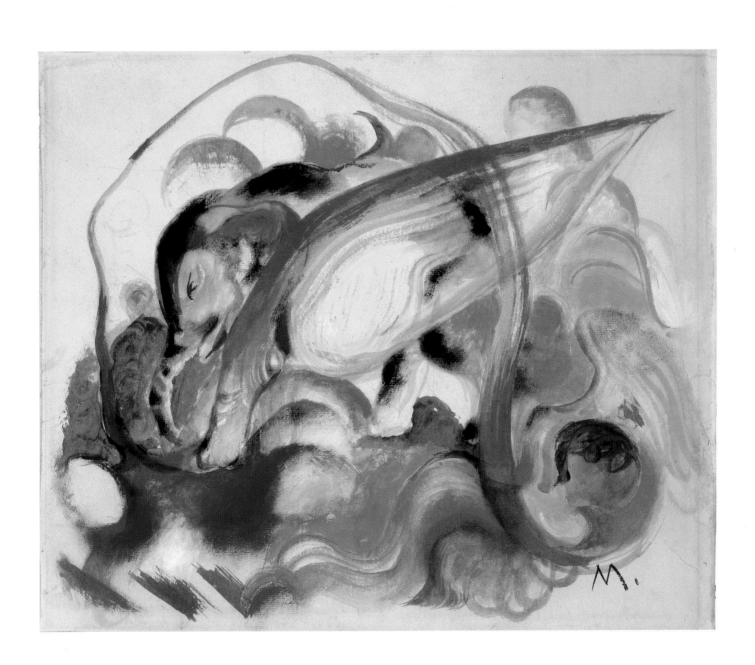

ROGER DE LA FRESNAYE
French, 1885–1925

L'Artilleur (The Artilleryman), 1917

Prior to his enlistment in the infantry in 1914, Roger de la Fresnaye was associated with the Cubist movement in Paris. After a wartime hiatus of nearly three years, he resumed drawing and painting in 1917. Throughout 1917, soldiers at leisure, whether playing cards, drinking in a café, or merely smoking, provided la Fresnaye with his most prevalent theme. Several variations of the soldier smoking a pipe in *L'Artilleur (The Artilleryman)*, for example, date from the period.[1] Although la Fresnaye characteristically refrains from showing the horrific aspects of war in *L'Artilleur*, the underlying war-related tension is suggested graphically by the soldier's clawlike hand and startled expression.

Certain elements of the drawing recall an earlier painting by la Fresnaye, *La Conquête de l'air (The Conquest of the Air)*, 1913.[2] The Cézannesque viewpoint from above the rooftops; the unattached flag suspended in the air; the flat, semicircular clouds; and the distant church steeple all find counterparts in the painting. Other elements have been transformed—the small round balloon in the painting has become the end of the cannon in *L'Artilleur*, and the curvilinear shape of a tall tree is echoed in the drawing in the contours of the soldier's pant leg.

The style of *L'Artilleur* reflects la Fresnaye's prewar interest in Cubism in the attempt to integrate the figure into the surrounding space and in the deployment of shifting planes. Realistic details, often whimsical, provide clues to the identity of the objects represented. Still, la Fresnaye makes only limited use of Cubist principles, incorporating them into a personal style that relies as well on the work of Paul Cézanne and older artistic traditions. AC

1 Germain Seligman, *Roger de la Fresnaye* (London: Thames and Hudson, 1969), nos. 244, 245.
2 Ibid., no. 137.

Pen and ink
11½ x 7⅝ (29.2 x 19.5)
Inscribed lower right in ink: *"L'artilleur"/26 Août 17/R. de la Fresnaye*
Inv. no. 1943:6
Gift of A. Conger Goodyear

Provenance: Joseph Hessel, Paris; de Hauke and Co., Paris, 1929;
A. Conger Goodyear, New York, 1929; presented, 1943.

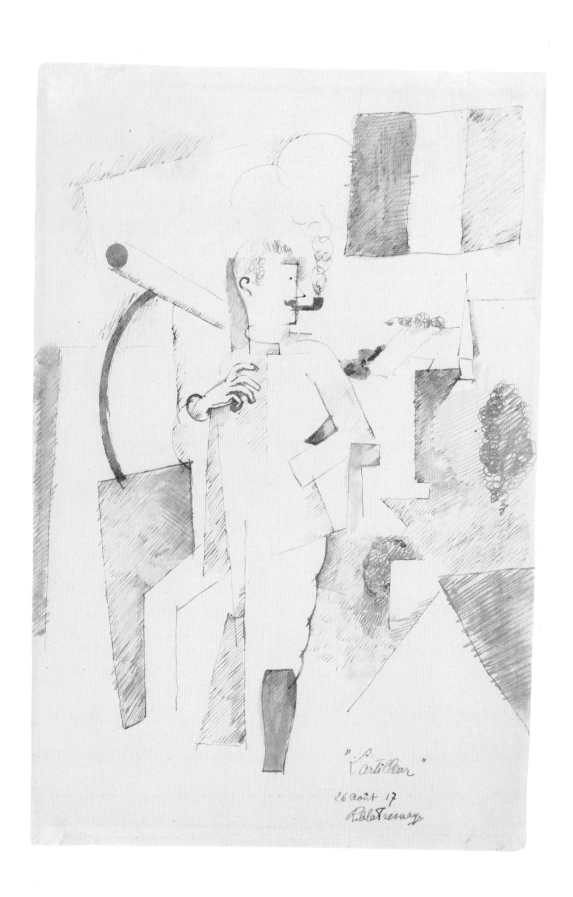

"L'artilleur"

26 Août 17

R de la Fresnaye

FERNAND LEGER
French, 1881–1955

La Flèche (The Arrow), 1919

Major compositions by Fernand Léger are frequently preceded by preliminary sketches and paintings. *La Flèche (The Arrow)* is a study for the oil painting *Le Passage à niveau (Level Crossing)*, also of 1919.[1] Major compositional elements and their relative placement in the painting have already been established in *La Flèche*, indicating that it is a late study.[2] Like the painting, the drawing ostensibly represents a railroad crossing. Although visual clues to the subject are fragmentary and elusive, the forms suggest the mechanized character of the railroad and its environs: metal pipes, steel girders, lettered signs, and wheels in motion. All are familiar forms in Léger's other works of the period.

The composition is based on contrasts: modeled versus unmodeled forms, recessive versus planar surfaces, and curved versus angular contours. The only wholly recognizable objects in the drawing are the arrow and its frame. By representing direction, and by implication movement, the arrow becomes a dynamic symbol appropriate to the theme.

The fragmented forms, presented in a shallow, shifting space, clearly suggest the noisy mechanical movement, flashing lights, and rapid succession of shapes one might glimpse from the window of a speeding train. Spatial relationships are unclear and sometimes contradictory, and the forms themselves seem to vacillate between abstraction and representation, yet the drawing emphatically conveys the sense of an industrialized, urban landscape. AC

1 Art Institute of Chicago.

2 In contrast, an elaborate oil study of the same painting inverts many of the same elements; see *F. Léger* (Basel: Galerie Beyeler, 1970), pl. 15.

Pen and ink wash
12 x 16⅜ (30.5 x 41.7)
Inscribed lower right in ink: *F. LEGER/19*
Inv. no. 1954:1.2
Gift of A. Conger Goodyear

Provenance: Jeanne Bucher, Paris; A. Conger Goodyear,
New York, 1931; presented, 1954.

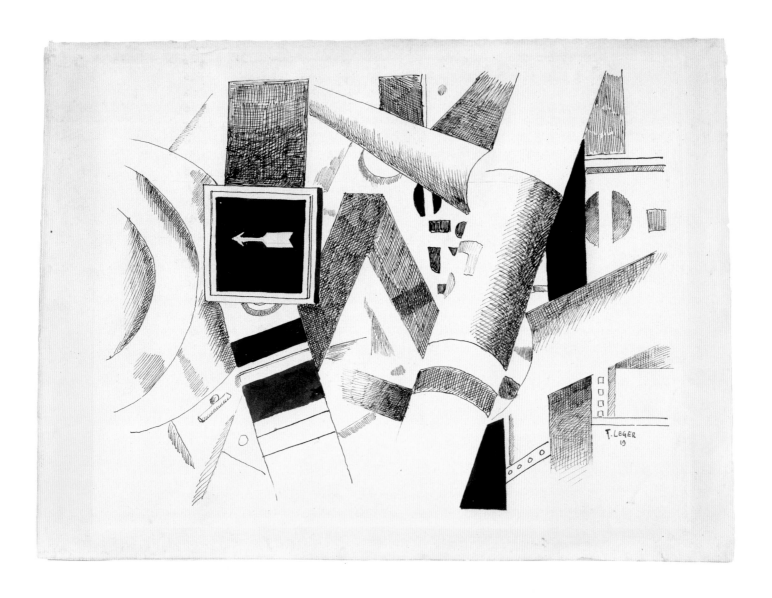

RAOUL DUFY

French, 1877–1953

Hommage à Mozart (Homage to Mozart), c. 1915

Musical themes pervade the work of Raoul Dufy in references ranging from simple musical allusions to elaborate depictions of full orchestras. *Hommage à Mozart (Homage to Mozart)* is one of a series of paintings in which the artist pays tribute to famous composers. Dufy's admiration for Mozart inspired a number of works, including two oil paintings that are particularly close to the Gallery's watercolor.[1]

Hommage à Mozart reflects Dufy's gradual liberation from a Cézannesque style. Once confined to a muted palette of greens and ochers, his range has expanded here, reflecting an earlier immersion in the vivid colors of Fauvism. In many respects a transitional work, the painting—with its wide areas of rich, unmodeled color that incorporate different objects within a single hue—heralds Dufy's mature style of the late 1920s. The free, calligraphic line that will become Dufy's trademark also plays an important role here, animating the scene with its lively decorative and expressive power.

Dufy's exuberant style seems especially well suited to the theme; the fractured planes, linear rhythms, and freely floating motifs convey a spontaneity and a verve that eloquently evoke Mozart's exquisite compositions. The artist delights in the decorative attributes of the violin and the piano, playing dark against light and concave against convex; both instruments are translated into a wealth of detail that lends an elegant, baroque air to the painting. Set off by a dramatic backdrop of rich, crystalline washes, the dazzlingly white sculptured bust seems to shine with an incandescent glow. AC

1 See *Raoul Dufy* (London: Arts Council of Great Britain, 1983), nos. 43, 44.

Watercolor and pen and ink
25¹¹⁄₁₆ x 20¹⁄₁₆ (65.8 x 50.8)
Inscribed lower right in ink: *Raoul Dufy/1915*
Inv. no. RCA 1939:13.7
Room of Contemporary Art Fund

Provenance: Nico Mazaraki, Paris; purchased, 1939.

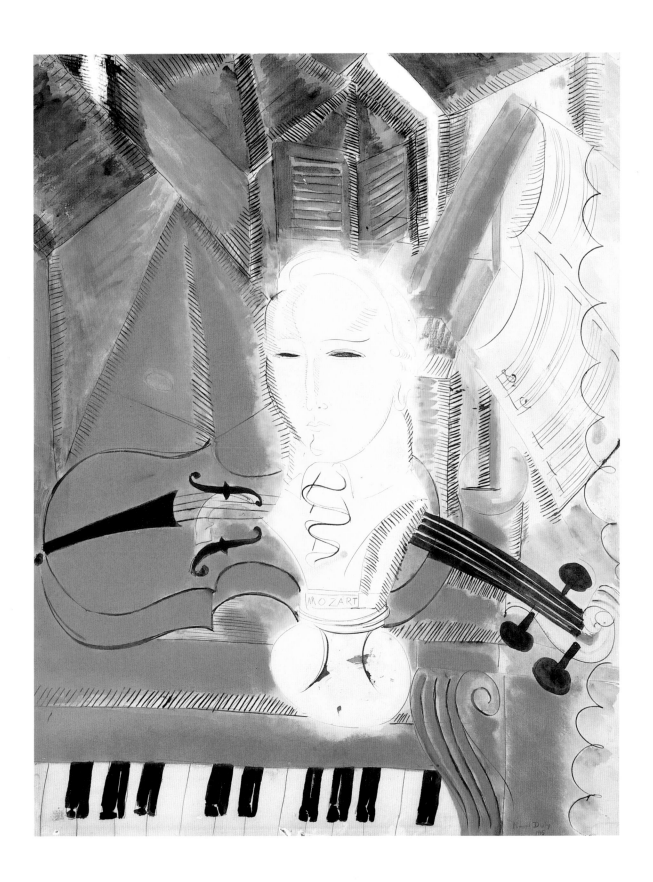

HENRI MATISSE

French, 1869–1954

Tête de femme (Head of a Woman), **1919**

The sensuous young woman with the compelling eyes in *Tête de femme (Head of a Woman)* is surely Antoinette, the subject of Henri Matisse's famed "Plumed Hat" series of 1919, a suite of about twenty drawings and four paintings in which the model wears an elaborate feathered hat.[1] She also appears in other works of that year, often dressed in exotic costumes. The works are remarkable for their eloquent expression of a wide range of mood and emotion, conveyed in a variety of styles.

This drawing is particularly close to a bust-length pencil sketch depicting a three-quarter view of Antoinette with her long hair tied in a bow.[2] Although the image is cropped, enough of Antoinette's hair and bow are visible in the Gallery's drawing to verify her identity. Both drawings feature the model's distinctive characteristics: full lips, slightly misaligned eyes, and enigmatic expression.

The Gallery's drawing is exceptional in composition and impact. Antoinette's gaze seems paradoxically both to meet the viewer's eyes and to be directed inward, thereby enhancing the mystery and fascination of the work. Extreme cropping allows the image to push beyond the boundaries of the paper and to enter psychologically the space of the viewer. This effect is heightened by the dramatic placement of the figure at the far left of the paper. The immediacy of the resulting image produces a powerful portrait of the young Antoinette that ranks among Matisse's loveliest and most intriguing visions. AC

[1] In December 1916 Matisse began spending the winter months in Nice, France. When he returned to Issy-les-Moulineaux for the summer and fall of 1919, Antoinette accompanied him. See Alfred H. Barr, Jr., *Matisse: His Art and His Public* (New York: Museum of Modern Art, 1951), pp. 204–6; and John Elderfield, *The Drawings of Henri Matisse* (New York: Museum of Modern Art in association with the Arts Council of Great Britain and Thames and Hudson, 1984), p. 264.

[2] Elderfield, *Drawings of Henri Matisse*, p. 174, no. 55.

Chinese ink and brush
10⅝ x 14½ (27 x 36.6)
Inscribed lower right in pencil: *Henri Matisse*
Inv. no. RCA 1940:3f
Gift of A. Conger Goodyear to the Room of Contemporary Art

Provenance: Le Nouvel Essor, Paris; A. Conger Goodyear,
New York, 1937; presented, 1940.

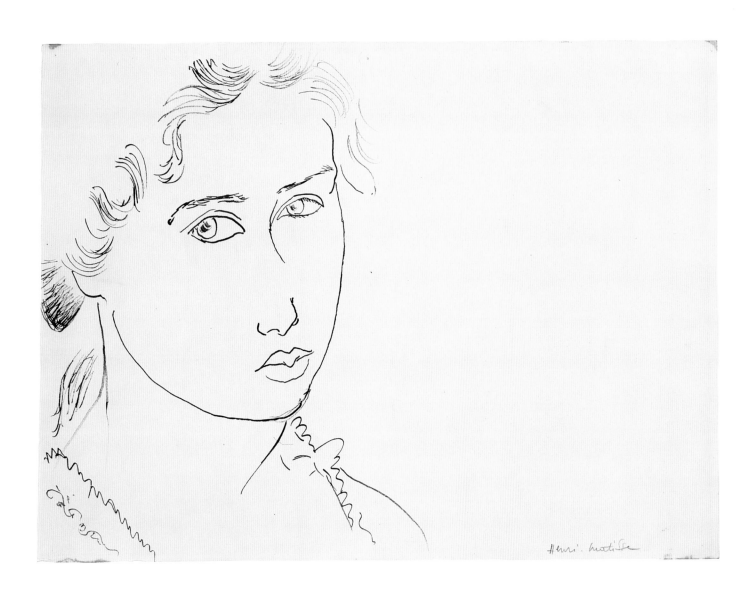

SONIA DELAUNAY
French, born Ukraine, 1885–1979

Danseuse, deuxième version (Dancer, Second Version), 1916

Danseuse, deuxième version (Dancer, Second Version) belongs to Sonia Delaunay's Iberian period, from 1914 to 1920 when she lived in Spain and Portugal. Enchanted by the region's radiant light and peasant culture, Delaunay responded eagerly to the forms and colors about her. Dancers, specifically flamenco dancers, were a favorite theme during the period.[1] Their twirling skirts and rhythmic movements inspired a series of colorful works, including *Danseuse, deuxième version.*

The Gallery's painting is particularly close to a smaller *Danseuse* of 1916—presumably the "first version"—in the Musée National d'Art Moderne, Paris.[2] Freer and sketchier, the Paris version betrays its origins in the image of a dancing figure more readily than the Gallery's painting. The long diagonal that bisects the composition of *Danseuse, deuxième version* terminates in the exposed leg and foot of the performer, the concentric rings that whip about the axis suggesting her colorful, whirling skirts. The dancer's head, breasts, and belly are represented by circles and semicircles, pictorial devices that reappear in paintings and costume designs by Delaunay, most spectacularly in her celebrated Cleopatra costume of 1918.[3]

As always in Delaunay's work, the colors have been carefully chosen, juxtaposed, and varied to activate the dynamic rhythms of the composition. Her skillful manipulation of color reflects years of experimentation. Like her husband, Robert, who articulated the theory of Simultaneity, Sonia Delaunay was guided by the principle of the simultaneous contrast of color. Applying this principle in *Danseuse, deuxième version*, she is able to suggest the rhythm and movement of a spinning dancer through color alone. AC

1 In 1913 in Paris, Delaunay produced several works on the theme of dance, finding particular inspiration in the crowds of dancers at the Bal Bullier.

2 See Arthur A. Cohen, *Sonia Delaunay* (New York: Harry N. Abrams, 1975), pl. 99.

3 The costume was designed for a restaging of the Diaghilev ballet *Cléopâtre.*

Tempera, chalk, and charcoal on heavy paper
22⅝ x 19⁵⁄₁₆ (57.4 x 49.1)
Not inscribed
Inv. no. 1980:19
George B. and Jenny R. Mathews and Evelyn Rumsey Cary Funds

Provenance: Rose Fried Gallery, New York; Paul Kantor, Los Angeles;
B. C. Holland, Chicago; Susanne Hilberry Gallery, Birmingham,
Michigan, 1977; purchased, 1980.

FRANCIS PICABIA
French, 1879–1953

Composition mécanique (Mechanical Composition), 1919

Composition mécanique (Mechanical Composition), 1919, belongs to a large group of works by Francis Picabia that have been labeled machinist. Convinced by 1915 that "the genius of the modern world is in machinery,"[1] Picabia sought inspiration from its forms. Machinery, mechanical parts, manufactured objects, and technical diagrams all provided visual and symbolic models for his works between 1915 and 1923.

The asymmetrical composition and draftsmanlike precision of Composition mécanique are characteristic of many of Picabia's late machinist works. Geometric forms are carefully balanced, the off-center rod and ball acting as a visual fulcrum for the other shapes. Subtle modulations in the wash and variations in the internal lines of the semicircular forms contribute to a sense of optical rotation. Freely undulating lines offer an intriguing contrast to precise geometric forms.

Symbolic content, often of a sexual nature, is nearly always present in Picabia's machinist works, which are more comments on man and his condition than they are descriptions of actual machines. The symbolism and source of inspiration for Composition mécanique, however, are unknown. The work suggests electrically charged energy, as if the black ball generates the power that seems to radiate from each core in concentric waves.[2] The organically suggestive shape that enlivens the rectangular box at the lower right adds a piquant touch, as it seems to originate from the energy coursing through the wires. Whatever the mechanical symbolism of the drawing, however, the aesthetic attributes are evident. None of the cryptic inscriptions commonly found in Picabia's machinist works intrudes to disrupt the clarity and beauty of the design. AC

1 Francis Picabia, interview in New York Tribune, 24 Oct. 1915; cited in William A. Camfield, Francis Picabia: His Art, Life, and Times (Princeton, N.J.: Princeton University Press, 1979), p. 77.

2 Two closely related drawings, also of 1919, feature similar forms; see Francis Picabia (Düsseldorf: Städtische Kunsthalle, 1983), nos. 32, 33.

Pen and ink wash
10 x 14¹⁵⁄₁₆ (25.4 x 37.9)
Inscribed lower right in ink: F. Picabia/19
Inv. no. 1970:3
Elisabeth H. Gates Fund

Provenance: Vicomte Alain de Léché, Paris; Michael Tollemache, London; purchased, 1970.

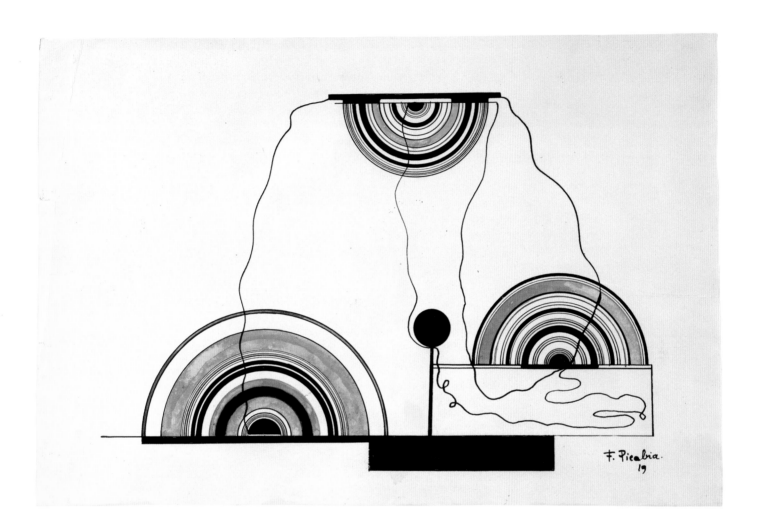

JACQUES LIPCHITZ
French, born Lithuania, 1891–1973

Etude de statue (Study for Statue), 1919

A native of Lithuania, the sculptor Jacques Lipchitz emigrated in 1909 to Paris, where he began formal training in art. By late 1914 he was working in a Cubist mode, a style he was to explore and refine with great success in the years to follow. Like the 1919 *Etude de statue (Study for Statue)*, many of his drawings from the period seem to have been made with a Cubist sculpture in mind.

In *Etude de statue* Lipchitz appears to be working out the major axes, planes, and curves for a planned sculpture, perhaps his *Femme drapée* of the same year.[1] Like the bronze statue, the drawing represents a draped standing figure with one arm bending across her body and the other curving downward along her side. The figure has been drawn over a rectangle of light gray and enclosed by a faint brown frame that has been freely drawn with a nearly dry brush. Working within this strong vertical axis, Lipchitz has plotted a grid of secondary diagonal axes and a network of interlocking planes. The major directional lines have been boldly emphasized over the heavily worked pencil drawing. The outline clarifies those planes that would protrude and recede in a sculptured version of the figure, creating a counterplay of abstracted three-dimensional shapes.

Despite the Cubist faceting and the slight displacement of geometrized body parts, the proportions of the figure suggest a human norm. The massive sculptural quality of the figure recalls Pablo Picasso's paintings of 1908–9, while the broad shoulders, pinched waist, and stylized features suggest as well the influence of Lipchitz's own documented interest in primitive art. AC

[1] See A. M. Hammacher, *Jacques Lipchitz: His Sculpture* (New York: Harry N. Abrams, 1960), fig. 27.

Pencil and watercolor
13⁵⁄₁₆ x 10¼ (33.9 x 26.2)
Inscribed upper right in pencil: *J Lipchitz*
Inv. no. 1977:7
Norman Boasberg Fund

Provenance: From the artist to J. L. Heitschel, Paris; Marlborough Gallery, New York; purchased; 1977.

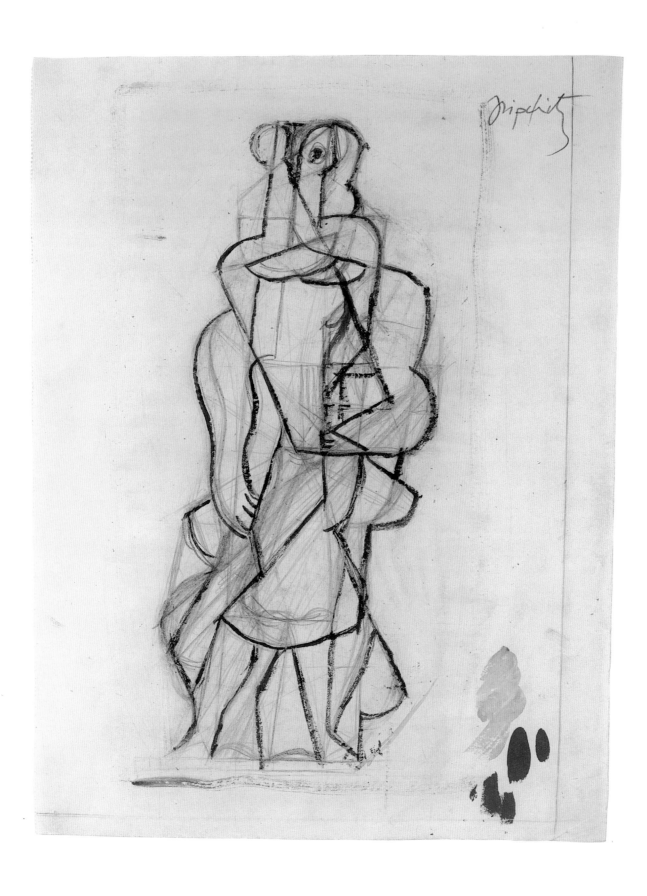

MARIUS DE ZAYAS
Mexican, 1880–1961

Portrait of Paul Haviland, c. 1913

Marius de Zayas held a unique position in the American avant-garde as an author, adviser, art dealer, and artist. He gained recognition in New York—as he had in his native Mexico—for his biting illustrations and caricatures. Associated with the Stieglitz circle, he was zealous in his promotion of modern art. He traveled in 1910 to Europe, where he studied and embraced Modernism and was a friend of several artists, including Pablo Picasso. In 1916 de Zayas published one of the first books on the impact of African sculpture on contemporary art and arranged the first exhibition of African art in America. Together with Paul Haviland, the subject of the Gallery's portrait, and Agnes Ernst Meyer, de Zayas carried on the spirit of Alfred Stieglitz's 291 gallery after Stieglitz's fervor subsided. De Zayas helped establish a progressive periodical entitled *291* to continue the legacy of Stieglitz's *Camera Work* and founded two commercial art galleries whose goals were similar to those of 291.

Portrait of Paul Haviland is an example of the abstract caricatures exhibited in de Zayas's third and final exhibition at 291 in 1913. A dramatic departure from his earlier work, which he felt addressed only physical appearances, these caricatures were "a graphical and plastic synthesis" of the artist's analysis of his subject.[1] They were composed of abstract elements representing the three intrinsic characteristics of his subject: spirit, matter, and intellect. Algebraic formulas represented the subject's spirit; the material self was rendered with geometric equivalents, inspired by a visual stimulus unique to the subject; the "initial force" or intellect of the individual was communicated by trajectories within a drawn rectangle.[2]

Haviland, the American representative for the Haviland porcelain factory in Limoges, France, was an ardent supporter of Stieglitz and the cause of modern art. In 1913 de Zayas and Haviland coauthored a booklet, published by Stieglitz, entitled *A Study of the Modern Evolution of Plastic Expression.* **CB**

1 Marius de Zayas, "Caricature: Absolute and Relative," *Camera Work*, no. 46 (Apr. 1914): 21.
2 Ibid.

Charcoal with *estompe* work on yellow paper
24⅝ x 18¾ (62.5 x 47.5)
Not inscribed
Inv. no. 1975:9
James G. Forsyth and Charlotte B. Watson Funds

Provenance: Galerie Jean Chauvelin, Paris; purchased, 1975.

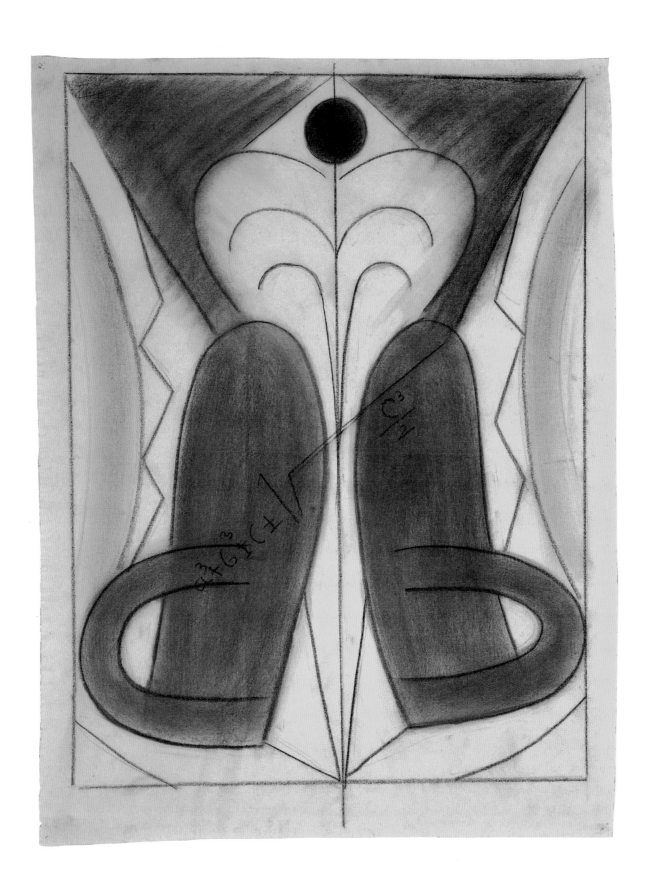

OSCAR BLUEMNER
American, born Germany, 1867–1938

Study for Old Canal, Red & Green, 1916

Oscar Bluemner, one of America's leading Modernists, is best known for his brilliant palette and highly structured compositions. While a practicing architect, he became intimately associated with the artistic vanguard of this country, frequenting Alfred Stieglitz's 291 gallery and regularly contributing essays to avant-garde journals to promote and explain modern art.

In 1915, following a one-artist exhibition of eight oil paintings at 291, Bluemner moved from New York to Bloomfield, New Jersey, where his mature style developed. An oil painting completed late in 1916, for which this watercolor is a study, was one of a series of canvases Bluemner started in 1911 and repainted after the evolution and definition of his vision. Originally titled *Sayreville, N.J.*, the revised version of the canvas was considered by the artist to be so successful that he deemed it his first official oil and retitled it *Old Canal, Red & Green*.

As was his method with other paintings from this period, the origin of this abstract industrial landscape was a small ink sketch rendered from observation. The clarification of his concept of space and the transformation of the natural and man-made elements of his landscapes into a composition of geometric planes occurred in a series of charcoal sketches culminating in this watercolor and gouache study. According to an entry in his painting diary, Bluemner felt that *Old Canal, Red & Green* was at first unresolved, with a "disunified appearance" and "motley" coloring.[1] The entry continues with a description of his adjustments that also describes this work, perhaps indicating the artist's reliance upon the study for continual experimentation.

Later Bluemner elaborated on his love of painting the landscape, describing it as "a blending of interest in nature or delight in its beauty with the person's craving for spiritual expression through pure artistic action. Thus, 'landscape' is the artform of modern emotional life."[2] **CB**

[1] Jeffrey Russell Hayes, *Oscar Bluemner: Life, Art, and Theory* (Ann Arbor, Mich.: University Microfilms International, 1982), p. 232.

[2] Ibid., p. 233.

Watercolor and gouache
5¼ x 7⅝ (13.4 x 19.5)
Inscribed lower left of image in pencil: monogram of artist; lower
left in ink: *Studie/? für/Bild/Sayreville/Southriver/14 x 20 öl/Jan-17*
Inv. no. 1985:4
Charles Clifton Fund

Provenance: James Barco, Charlottesville, Virginia; Kraushaar Galleries,
New York, 1974; Charles Borrock, New York, 1976; Barbara Mathes
Gallery, New York, 1985; purchased, 1985.

Studie
R. für
Bild
Sapperville
Südseite
14 x 20 öl
Jan -17

GIFFORD BEAL

American, 1879–1956

Armistice Day, 1918, 1918

On November 11, 1918, in the early hours of the morning, the armistice agreement that heralded the end of the Great War was announced in New York. Within minutes, the searchlights on top of the New York Times building were streaking across the sky, and sirens awakened those who slept, drawing them forth to join others in a spontaneous early morning celebration. Throughout the following day, crowds thronged the ‚streets, and parades traveled up the avenues. Warships and merchant vessels anchored in the Hudson River were decked with flags. At night the city, which had remained mostly dark during the war, was lit up in a blaze of lights.

Gifford Beal, a native of New York, captured this euphoric, festive atmosphere in his watercolor painting *Armistice Day, 1918*. Appropriately, he depicted the city in terms of light, with skyscrapers emerging out of the nighttime darkness. A smattering of brilliant yellow dots indicates street lamps and lighted windows, and the Red Cross banners and building facades in the foreground glow as if illuminated by spot- or searchlights. Beal used both white and colored gouache as well as overlays of thin washes to create these effects. His cursory treatment of the buildings and crowds— mere dabs of color—borders on abstraction.

A student of William Merritt Chase, Beal worked in both oil and watercolor. His techniques ranged from a spontaneous, dashing stroke, somewhat like his teacher's, to a still distinct, but more tightly modeled, handling of paint. Equally catholic in his choice of subject matter, Beal enjoyed painting seafarers, circus scenes, and landscapes. Nevertheless, in almost all instances, his manner of representation remained descriptive. *Armistice Day, 1918*, which nearly dissolves into pure light and color, stands apart as an unusual example of Beal's art. HR

Watercolor and gouache

15⅝ x 22¼ (39.7 x 56.5)

Inscribed lower left in watercolor: *GIFFORD BEAL 18*

Inv. no. RCA 1963:3

Gift of Mrs. Howell H. Howard to the Room of Contemporary Art

Provenance: Mrs. Howell H. Howard, New York; presented, 1963.

WALT KUHN
American, 1877–1949

Revery, c. 1914

T his pastel drawing dates from the period immediately following the Armory Show, with which Walt Kuhn was deeply involved. Along with Arthur B. Davies and many of his contemporaries, he believed that his burning desire "to be informed of the slightly known activities abroad and the need of breaking down the stifling and smug condition of local art affairs" would be satisfied only by his own efforts.[1] The Armory Show was a controversial and profoundly significant event in the history of modern art, and Kuhn became widely known for his zealous dedication to the future of modern art in America.

Kuhn considered drawing to be integral to the study of painting and drew each day, earning a living before 1914 by rendering cartoons for popular periodicals. The number of the artist's drawings that survive compared with the number he created is small, however, because of his continual, harsh critical review of his own work and the fact that he destroyed those drawings that did not meet his standards. By the artist's own wishes, his drawings were infrequently exhibited during his lifetime, despite their significance in relation to his paintings, which were widely exhibited.

As is evident in his penetrating portraits of costumed models and especially in this sensuous line drawing, Kuhn's primary subject was the emotional and psychological character of his sitter. Although *Revery* is a simple composition, quickly sketched, the mastery of Kuhn's draftsmanship is readily apparent. The fluid lines are applied with assuredness and apparent ease. Unlike his better-known subjects—the acrobats, dancers, and clowns that appear regularly in his later work—he has concentrated here on the ordinary. With brown pastel and highlights of lavender and yellow, Kuhn has rendered his model's distinct features with great affection and delight.

This pastel was purchased by the collector John Quinn soon after its completion.[2] It was one of more than thirty paintings and drawings by Kuhn in Quinn's collection.[3] **CB**

1 Walt Kuhn, *The Story of the Armory Show* (New York, 1938).

2 Judith Zilczer, *"The Noble Buyer": John Quinn, Patron of the Avant-Garde* (Washington, D.C.: Smithsonian Institution Press, 1978), p. 169.

3 *Paintings and Sculptures: The Renowned Collection of Modern and Ultra-Modern Art Formed by the Late John Quinn* (New York: American Art Association, 1927).

Pastel
17¼ x 12⅞ (43.6 x 32.7)
Inscribed lower right in pencil: *Walt Kuhn*
Inv. no. 1970:2.36
Bequest of A. Conger Goodyear

Provenance: John Quinn, New York, 1916; A. Conger Goodyear, Buffalo, 1927; bequest, 1970.

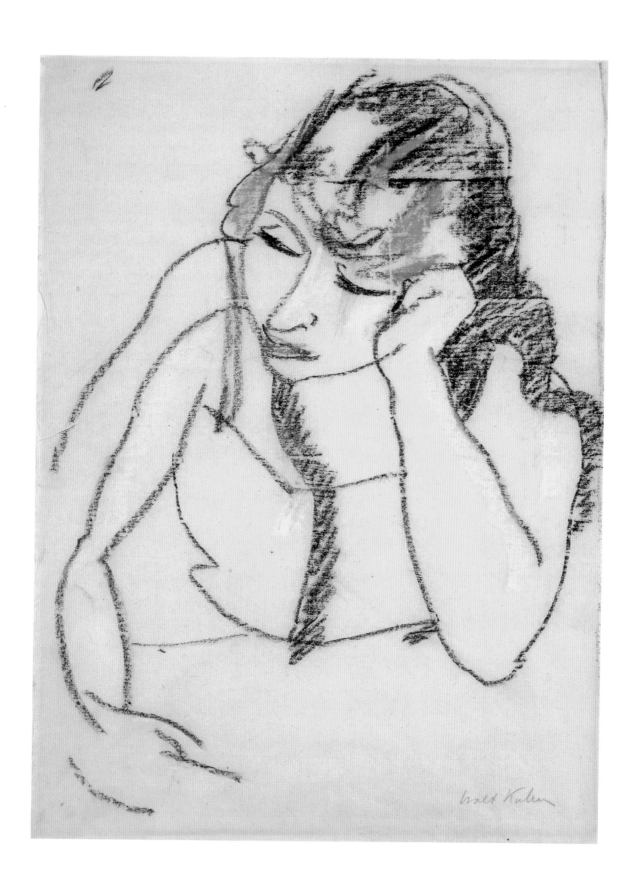

GASTON LACHAISE
American, born France, 1882–1935

Mask, c. 1922–27

Although primarily a sculptor, Gaston Lachaise also produced copious drawings, usually depicting lush, provocative nudes similar to those in his sculpture. *Mask* represents something of an anomaly, as it relates more closely to his portrait busts and masks than to his ebulliently sexual full-figure sculptures. It has been suggested that *Mask* might in fact be a study for an alabaster mask of Marie Pierce completed by Lachaise in 1922.[1] His wife's niece, Marie Pierce was one of the artist's favorite models for portrait studies. Between 1922 and 1927 she was the model for three plaster busts and a number of masks made in alabaster or in variously patinated bronze.[2] The masks show a progressive simplification, and the later masks, in particular, suggest an oriental influence.[3]

Mask, with its oriental flavor and concise rendering, shares some of the traits of the sculptural masks. Lachaise did not date his drawing, but it seems likely that he executed *Mask* during the same period as the related fragmentary sculptures. However, attempts to link *Mask* with a specific sculpture pose a problem. Drawing, for Lachaise, was an activity separate from sculpture. While his drawings often are similar to his sculptures, they rarely served as studies. *Mask* may follow the same theme as his stone and metal masks; however, the features differ from those of Marie Pierce and reveal a far more generalized and pronounced oriental influence.

Despite its nonsexual subject matter, *Mask* possesses the same sensuousness and exquisite decorative quality found in Lachaise's nude drawings. He suggests sculptural mass and voluptuously curving form through the use of line alone. His employment in 1905 in the shop of the famous Art Nouveau designer René Lalique undoubtedly contributed to the development of this expressive, sinuous line. Succinct, assured, and sometimes playful, Lachaise's elegant calligraphic style has frequently been compared with that of Henri Matisse and Auguste Rodin. HR

1 Letter from Harry A. Brooks to Marjorie J. Huston, 28 Mar. 1972, in the Gallery files.

2 Carolyn Kinder Carr, "Gaston Lachaise: Portrait Sculpture," in *Gaston Lachaise: Portrait Sculpture* (Washington, D.C.: National Portrait Gallery, Smithsonian Institution, in association with Smithsonian Institution Press, 1985), p. 14.

3 Ibid.

Pencil
21⅝ x 19⅛ (55 x 48.4) [not including 2⅜ (6.1) folded under at the top]
Inscribed lower center in pencil: *G Lachaise*
Inv. no. 1972:7.1
**Gift of Mr. and Mrs. Harry A. Brooks in fond remembrance of
Helen Northrup Knox**

Provenance: From the artist to Mme Isabel Dutaud Lachaise, New York,
1935; Harry A. Brooks, New York, c. 1946; presented by Mr. and Mrs.
Harry A. Brooks in fond remembrance of Helen Northrup Knox, 1972.

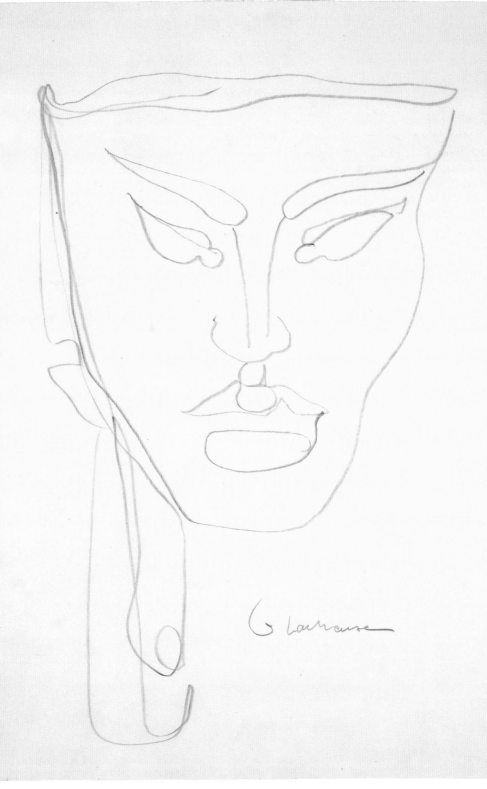

JOSEPH STELLA
American, born Italy, 1880–1946

Skyscrapers, c. 1920

Joseph Stella began his career as an illustrator of urban scenes for magazines. After a 1909 trip to Europe, where he first saw the work of Henri Matisse, Pablo Picasso, and the Italian Futurists, his style changed dramatically and soon after he became one of the leading figures of the then-burgeoning Modernist movement in the United States. From 1912 on he worked in modern styles that ranged from a mixture of Futurism and Cubism to a highly personal Symbolism, but his enthusiasm for the city as a subject remained constant. *Skyscrapers* is probably an early example of the studies in which Joseph Stella explored ideas for his monumental tribute to New York, a five-panel oil painting titled *New York Interpreted* (Newark Museum, New Jersey). Executed between 1920 and 1922, the painting and studies reflect Stella's longstanding ambition to translate the sights, sounds, and smells of the city into paint.

This watercolor depicts a bird's-eye view of the city's concrete and glass behemoths. The buildings, represented by simple geometric forms, appear less weighty and oppressively cramped than in the oil painting. Applied in flowing, transparent washes of gray and blue, the watercolor medium contributes to the airy feeling of the study. Although *Skyscrapers* introduces the strong vertical rhythms found in the later work, it avoids the dark, brooding overtones of *New York Interpreted*; Stella's inclusion of the pale swath of sky and his use of the paper to indicate the form of the stepped building in the background admit a sense of light-filled space. These effects suggest that here his response to skyscrapers is more positive, as expressed in one of his prose-poems:

When fog obliterates the bases of the skyscrapers they seem suspended in air, like brilliant jewel cases of destiny, like flaming meteorites held momentarily motionless in their tracks, like stars flung into the darkness of a tempestuous sky. And wide, geometric bands of shadow, moving like an invisible procession, mass, deepen, form and unform, float into view and disappear, while the metallic skeleton of the gigantic metropolis flashes with sparkling light that breaks out suddenly like the foam of a wave, like the flight of seagulls in a storm.[1] **HR**

[1] Cited in Irma B. Jaffe, *Joseph Stella* (Cambridge: Harvard University Press, 1970), p. 78.

Watercolor and pencil
23⅛ x 16⅝ (58.9 x 42.3)
Inscribed lower right in pencil: *Joseph Stella*
Inv. no. 1975:3
Charles Clifton and Edmund Hayes Funds

Provenance: Estate of the artist; Rabin and Krueger Gallery, Newark, New Jersey, c. 1946; Robert Schoelkopf Gallery, New York, 1962; purchased, 1975.

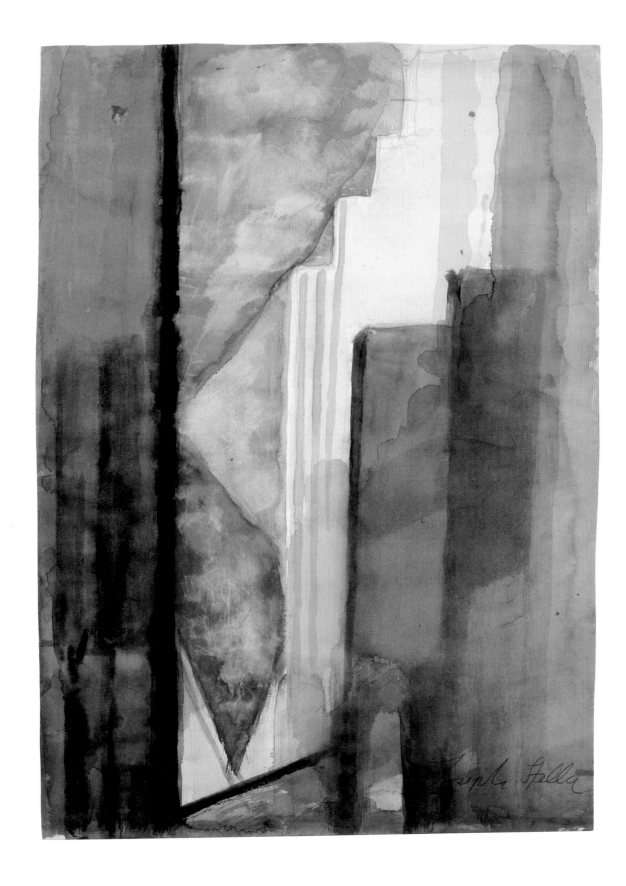

CHARLES SHEELER
American, 1883–1965

Barns (Fence in Foreground), 1917

Barns *(Fence in Foreground)* dates from the year in which the characteristic elements of Charles Sheeler's mature style were first in evidence. Concentrating on the nineteenth-century barns of Bucks County, Pennsylvania, Sheeler completed a series of drawings in 1917–18 that reveals his attention to the structure of functional architecture and the beginning of his expression of forms in a clean, precise, almost mechanical manner. Sheeler's unique style evolved from his understanding of the concepts of European Modernism, especially the Cubists' reduction of form and use of flattened space, and from his personal belief in the unchangeable order of the world. He was devoted to American subjects—industrial plants, vernacular architecture, and mundane objects—yet his aim was not to describe the American scene but to convey a personal impression and the essence of the familiar.

The purity of Sheeler's compositions was a result of his skill as a draftsman. Although he used pencil and tempera in his works on paper, he favored conté crayon because it enabled him to achieve a variety of lines and textures. Typical of his work in all media is the directness of his vision, expressed through frontal views; the detachment of his subject from atmosphere and locale; and, significantly, the manipulation of light on surfaces. The extreme contrasts of light and shadow are essential to his compositions; in the barn abstractions, light and shadow define and belie forms while appearing as substantial as the architecture. In later drawings, Sheeler demonstrated a remarkable mastery in rendering subtle values of light.

Sheeler was on the verge of professional recognition for his work as a painter and photographer at the time he completed this drawing. His development was nurtured by his contact with the avant-garde. Perhaps most enduring, however, was his native vision, which he shared with his friend, the poet William Carlos Williams. **CB**

Conté crayon
5½ x 8⅞ (14 x 22.6)
Inscribed lower right in pencil: *Sheeler 1917*
Inv. no. 1954:1.22
Gift of A. Conger Goodyear

Provenance: From the artist to the Society of Independent Artists,
New York, April 1917; John Quinn, New York, 1917; A. Conger Goodyear,
Buffalo, 1926; presented, 1954.

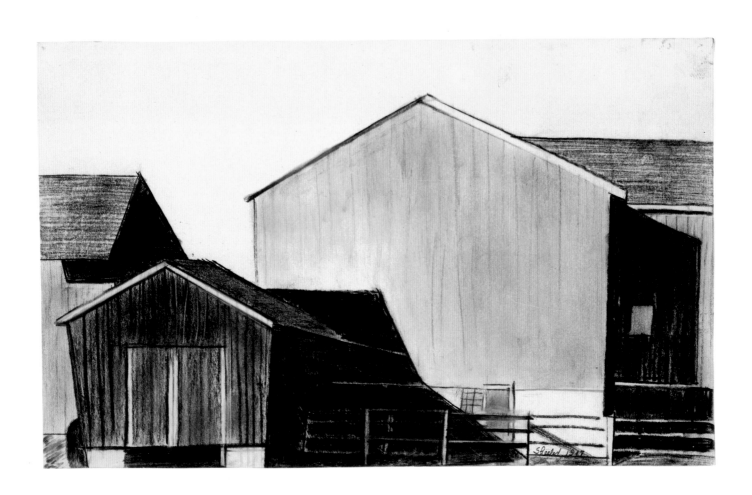

GEORGE BELLOWS

American, 1882–1925

Jean, c. 1920

George Bellows's pencil portrait of his daughter Jean reveals the same bold assurance as his paintings. Concise and energetic, his gestures with the pencil presage his muscular brushwork. Here, he indicates with thick and thin lines and a modicum of hatching the masses and tonal contrasts that he later translated into paint. *Jean* is a preparatory study for a monumental portrait (in the Gallery's collection) of his great-aunt Elinor, mother Anna, and five-year-old Jean. The faint grid penciled over the drawing demonstrates Bellows's interest in the compositional theories of Jay Hambidge, a Canadian-born artist who derived his principle of Dynamic Symmetry from a system of proportions that he observed in Greek art. According to this theory, a composition should be determined by the use of mathematical formulas based on the dimensions of the work and the proportions of the objects depicted. From 1918, when he first heard Hambidge's lectures, until his death in 1925, Bellows zealously adhered to this theory. Yet, despite the rigidity of the system he championed, Bellows retained his characteristic spontaneity in the portrayal of his subjects.

Known for his vital renderings of ordinary American life and scenery, Bellows was one of the most popular artists of his day. Born in Columbus, Ohio, he settled in New York in 1904. There he fell under the influence of the painter Robert Henri, who encouraged his pupils to develop their own styles. In 1913 Bellows became the youngest artist ever elected to the conservative National Academy of Design, although he had little use for the restrictive formulas of academic art. While he never moved beyond an expressionistic style into abstraction, Bellows retained an open mind regarding others' experiments and was instrumental in the organization of the exhibition of radically modern art held at the New York Armory in 1913. **HR**

Charcoal and pencil
19¾ x 12¼ (50.1 x 31.2)
Inscribed upper left in pencil: *large middi S9*
Inv. no. RCA 1940:3a
Gift of A. Conger Goodyear to the Room of Contemporary Art

Provenance: From the artist to Marie Sterner, New York, 1923; A. Conger Goodyear, Buffalo, 1924; presented, 1940.

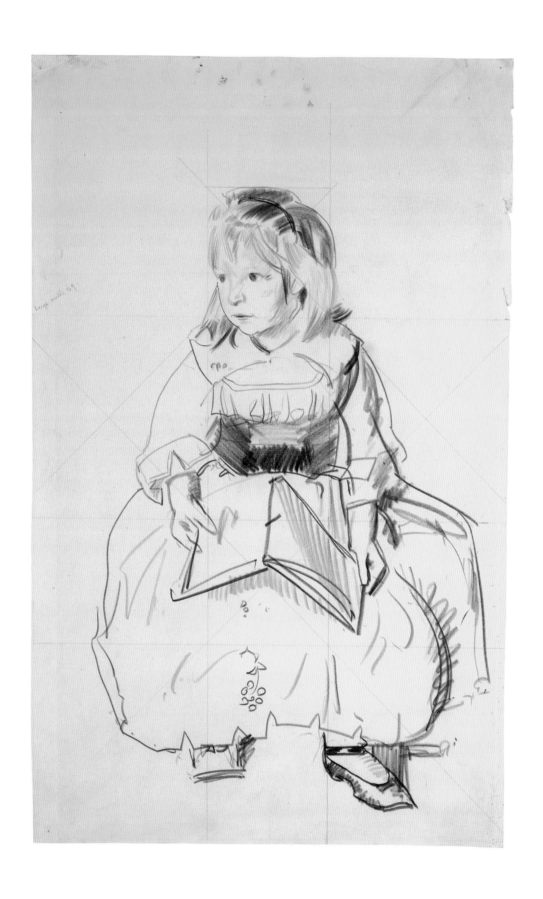

CHARLES DEMUTH
American, 1883–1935

Lancaster, **1921**

Charles Demuth's hometown, Lancaster, Pennsylvania, served the artist as a primary subject. As early as 1916 he focused on the typical urban architectural monuments surrounding him, rendering them in a Cubist-Realist manner that culminated in his work of 1920–21.

Although Demuth's images are recognizable and familiar, he rendered them in a fractured and precise manner with an almost fastidious application of paint, imparting to compositions a fragile appearance while leaving them void of sentimentality and emotion. It was his attraction to formal elements—the linear and angular images of industrial America—rather than an attraction to things American that provoked Demuth's attention to his immediate surroundings. He was familiar with European Modernism from his studies abroad and counted members of the early-twentieth-century avant-garde, including Marcel Duchamp and the poet William Carlos Williams, among his closest friends. Crucial to his development were the works of Paul Cézanne and the Cubists; many of his compositions acknowledge Cubist theory but only selectively incorporate its qualities.

Demuth frequently employed a variation on the Futurist's ray-line, using it in *Lancaster* to emphasize a recession of verticals. In this work Demuth has emphasized, and added, triangular and pyramidal shapes through the use of obvious gradations of tone within strict outlines. These forms and a repetition of elliptical shapes enhance the effect of energy barely contained within the boundaries of this composition.

Demuth's brilliant handling of watercolor in his earliest still lifes and in his later work reveals his affinity for the medium. His turn to tempera in 1919 resulted from his desire to satisfy a public prejudiced against the "lighter" watercolor medium yet still create hard-edged images. An assessment of the artist's watercolors by a reviewer in 1926 provides an apt description of Demuth's oeuvre: "The pellucid clarity of his acquarelles was touched with a strange and tremulous beauty . . . a perfect tranquility, a calm heightened by delicate flashes of gaiety."[1] **CB**

1 "Charles Demuth: Intimate Gallery," *Art News* 24, no. 27 (10 Apr. 1926): 7.

Tempera and pencil on paper on board
19⅞ x 16 (50.4 x 40.6)
Inscribed lower left in pencil: *C. Demuth 1921/Lancaster*
Inv. no. RCA 1944:12
Room of Contemporary Art Fund

Provenance: Robert E. Locher, Lancaster, Pennsylvania; C. W. Kraushaar
Art Galleries, New York; purchased, 1944.

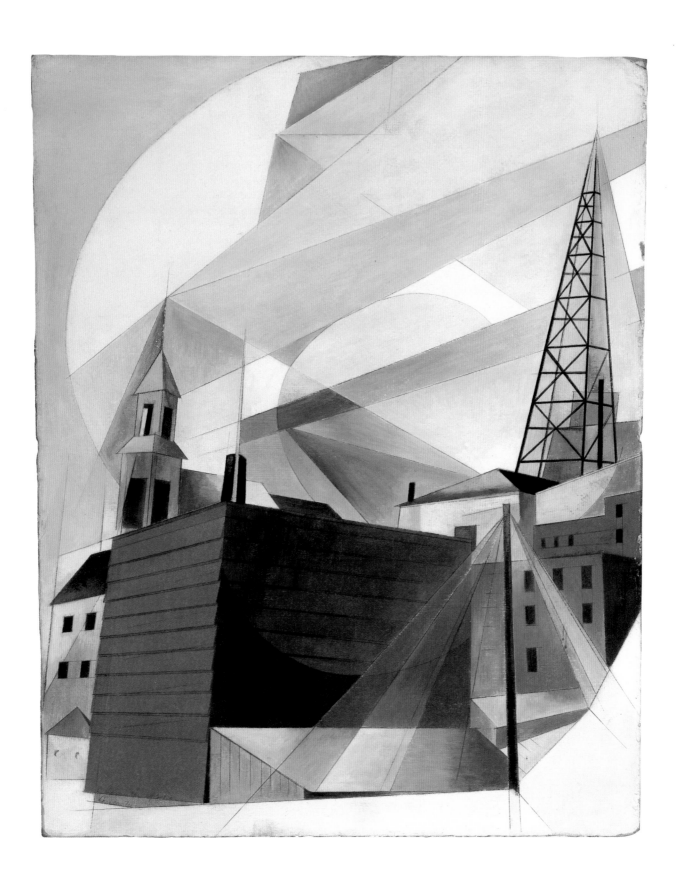

PRESTON DICKINSON
American, 1889–1930

Still Life, c. 1924

Still lifes and interior scenes as intimate reflections of the artist's own world were frequently depicted in the paintings, drawings, and prints of Preston Dickinson. His devotion to the familiar, which extended even to the landscape, was a vehicle by which the artist sought to refine technique.

The objects in the artist's still lifes provided the means for exploring shape, color, space, and composition. Dickinson's attention to the arrangement of planes of color in his work reflects his study of Paul Cézanne. An even stronger influence, as exemplified by this *Still Life*, were the unique design and spatial concepts of Japanese prints; their formal elements, including flattened, outlined shapes and highly patterned areas, became characteristic of Dickinson's work. Although he remained independent of any group, Dickinson was often associated with the Precisionists because of similarities in subject and style; like Charles Sheeler and Charles Demuth, he rendered sharply defined forms found in ordinary objects and in the industrial landscape. Yet Dickinson never fully embraced nor reflected the Cubist-Realist style of either artist.

Evident in *Still Life* are the artist's meticulous rendering of a carefully constructed arrangement and his mastery of the pastel medium. Fruits and vegetables such as oranges, eggplants, and turnips join sleek, man-made objects, including the salt shaker and pitcher seen frequently in Dickinson's compositions. A gleaming toaster, whose surface challenges depiction, complicates the artist's arrangement. Highlights of unusual color add vitality to the work.

Dickinson's focus was not confined in this work to the immediate objects but extended to their surroundings; the depiction of a simple interior of flattened space is contradicted by the implied depth of a back wall. Although it is a lively composition, a sense of loneliness is suggested by the inclusion of the nearby unoccupied chair. **CB**

Pastel and pencil
25⁵⁄₁₆ x 21³⁄₁₆ (64.3 x 53.7)
Inscribed center right in pencil: *P. Dickinson*
Inv. no. 1927:30
Charles W. Goodyear Fund

Provenance: From the artist to Daniel Gallery, New York; purchased, 1927.

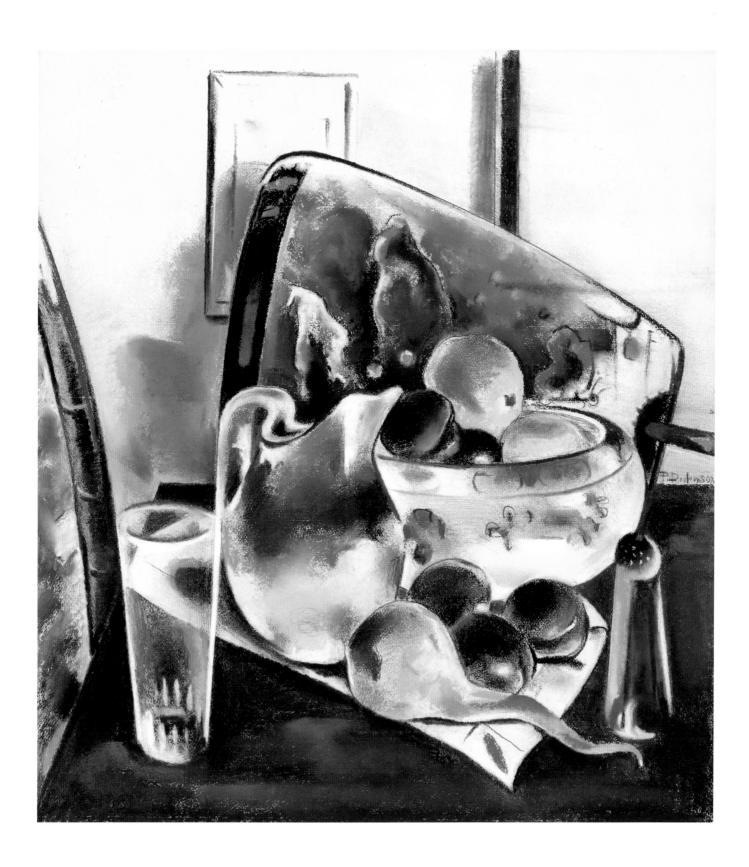

CHARLES BURCHFIELD
American, 1893–1967

Promenade, 1927–28

P*romenade* is one of the few artworks that Charles Burchfield completed in the 1920s. With a growing family and increased responsibilities following his promotion to head of the design department at M. H. Birge and Sons, a wallpaper company in Buffalo, Burchfield had little time for painting and drawing. His frustration led to his quitting his job in 1929 after eight years with the firm.

The artist's passionate expression of nature dominated his earliest works, and only in 1924, after residing in the Buffalo area for three years, did he feel capable of addressing the contemporary urban scene. He wrote in his journal in March 1926: "Now living in Gardenville and going back and forth on the bus, now is the time to live and do my best work, these people are the most interesting people on earth."[1]

A sensitivity to the economic hardships of the time and to the desolation of industrialized cities led to the somber tone of Burchfield's palette and his exaggeration of architectural details in his renderings of actual scenes in Buffalo. In *Promenade*, he exaggerated what he described as "the glassy quality" of the windows and the "eyebrows" over them in order to enhance the mournfulness he sensed in the typical, aging architecture.[2] While he took great delight in the depiction of a pack of dogs in pursuit of a leashed pet, the artist was dismayed by the wide popularity *Promenade* engendered, seemingly at the expense of works without such humorous overtones.[3] **CB**

[1] John I. H. Baur, *The Inlander: Life and Work of Charles Burchfield, 1893–1967* (Cranbury, N.J.: Associated University Presses and Cornwall Books, 1982), p. 135.

[2] "Burchfield's Buffalo," *Art News* 43, no. 6 (1–14 May 1944): 11.

[3] Baur, *Inlander*, p. 140.

Watercolor
31⅝ x 42½ (80 x 108)
Inscribed center right in watercolor: monogram of artist
Inv. no. 1977:20
Gift of A. Conger Goodyear

Provenance: From the artist to Montross Gallery, New York, 1928;
A. Conger Goodyear, New York, 1928; presented, 1977.

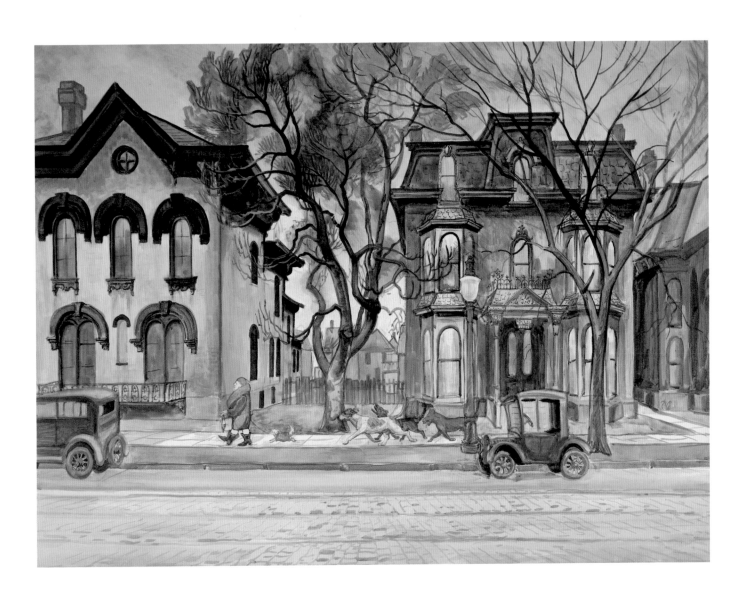

EDWARD HOPPER
American, 1882–1967

North Truro Station, c. 1931

The rail station at North Truro, Massachusetts, was an endearingly familiar sight to Edward Hopper. Many of the simple structures dotting the area of Cape Cod where he and his wife regularly summered were subject to his scrutiny and later translated into watercolor. Hopper's powers of observation were keen, but his renderings of architecture and interiors were not so much evidence of his appreciation of the vernacular as vehicles for "the most exact transcription possible of my most intimate impressions of nature."[1] As is characteristic of his work, the subject of *North Truro Station* is the intense, penetrating light of the moment and the feeling evoked by it, not the structure after which it is named.

Hopper was consistent in his choice of subjects, realizing early on that his strongest interest was in the drama of modern life. A student of Robert Henri, whose use of contemporary imagery involved a social commentary that profoundly influenced American art, Hopper was concerned with the emotional impact of a solitary figure in a simple interior or a majestic Victorian house in a barren landscape.

Hopper began etching while still a commercial illustrator, and it was in this medium that he first revealed his mastery of dramatic lighting through his use of dense black ink on white paper. Widespread recognition of his graphics encouraged Hopper to attempt in 1923 the medium of watercolor, which allowed him to paint out of doors, spontaneously. His method, as is apparent in the Gallery's work, was to sketch a scene in pencil, then apply an even, consistent layer of paint that would reveal little gesture. The first exhibition of his watercolors was held a year later, in 1924, at the Frank K. M. Rehn Gallery in New York. It sold out and marked the beginning of Hopper's long and successful artistic career. **CB**

1 Edward Hopper, cited in *Edward Hopper Retrospective Exhibition* (New York: Museum of Modern Art, 1933), p. 17.

Watercolor and pencil on watercolor paper
14 x 20 (35.5 x 50.8)
Inscribed lower left in watercolor over pencil:
Edward Hopper/North Truro
Inv. no. 1963:4
Gift of Mrs. Howell H. Howard

Provenance: Frank K. M. Rehn Gallery, New York; Mrs. Howell H. Howard, New York; presented, 1963.

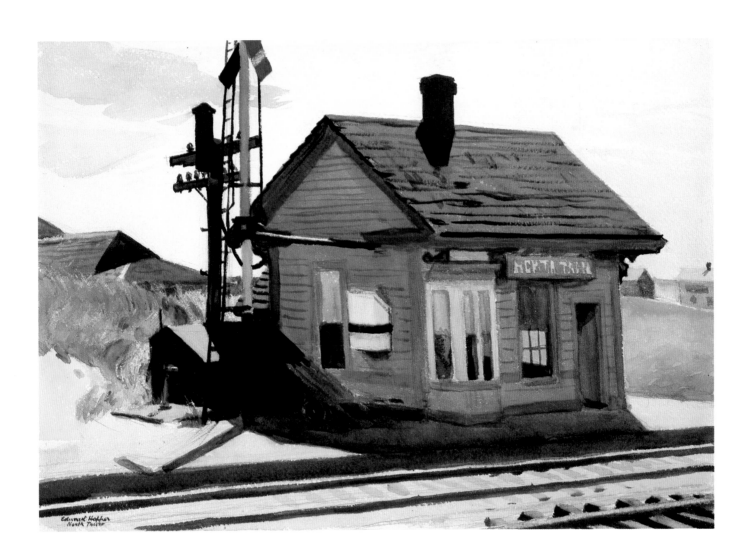

JOHN MARIN
American, 1870–1953

City Construction, 1932

By the time he completed *City Construction* in 1932, John Marin was already highly regarded for his brilliance as a watercolorist and for his uniquely modern "American" vision. Depicting both the urban and natural worlds, Marin continually revealed his love of place and, although working in an increasingly abstract manner, never entirely eliminated objective references in his work. He studied in Paris, and his earliest works reveal an attention to the dynamism of the Futurists and to a Cubist structuring of space; however, he soon evolved a style that, while acknowledging contemporary trends, was independent of his peers and was never to be imitated. The first one-artist exhibition of his watercolors took place at Alfred Stieglitz's 291 gallery in 1909, and thus began his lifelong friendship with one of this country's first champions of the avant-garde.

Perhaps of greater importance to Marin than his efforts in watercolor during the 1930s was his renewed interest in the medium of oil, which he explored primarily in land- and seascapes. *City Construction* is one of Marin's watercolors dating from this time, revealing his assured mastery of the medium and a new understanding derived from his experimentation with oil paint. The resulting composition appears spontaneously rendered and fresh, perhaps because it served as a welcome break from his struggles in oil and as a celebration of his skills.

Using the transparent washes typical of his work, in *City Construction* he created a surface extending from a "frame" to the paper's edge, encouraging a reading of exterior surface surrounding an interior view. This "frame-within-a-frame" device was present in Marin's work as early as the mid-1920s. Within its frame, Marin's city soars; dense yet discernible, his overlapping, projecting structures, rendered by drawing with a dry brush, are full of energy. Integral to the composition is the untouched white support that lends distinction to his forms as much as it creates the feeling of a light and airy view.

Similar in composition to another watercolor completed in the same year and based on a view of lower Manhattan,[1] *City Construction* was kept by the artist and never exhibited during his lifetime.[2] **CB**

1 See Sheldon Reich, *John Marin, Part II: Catalogue Raisonné* (Tucson: University of Arizona Press, 1970), p. 646, no. 32.37.

2 Letter from Edith G. Halpert, director of the Downtown Gallery, New York, to Albright-Knox Art Gallery, 18 Mar. 1954, in the Gallery files.

Watercolor on watercolor paper
26¾ x 21⅞ (68 x 55.6)
Inscribed lower right in watercolor: *Marin 32*; on verso center in
pencil [artist's hand?]: *More* [indecipherable]/*Lower Manhattan/1932*;
on verso lower right in pencil: *JMCC*
Inv. no. 1954:3
George Cary Fund

Provenance: Downtown Gallery, New York; purchased, 1954.

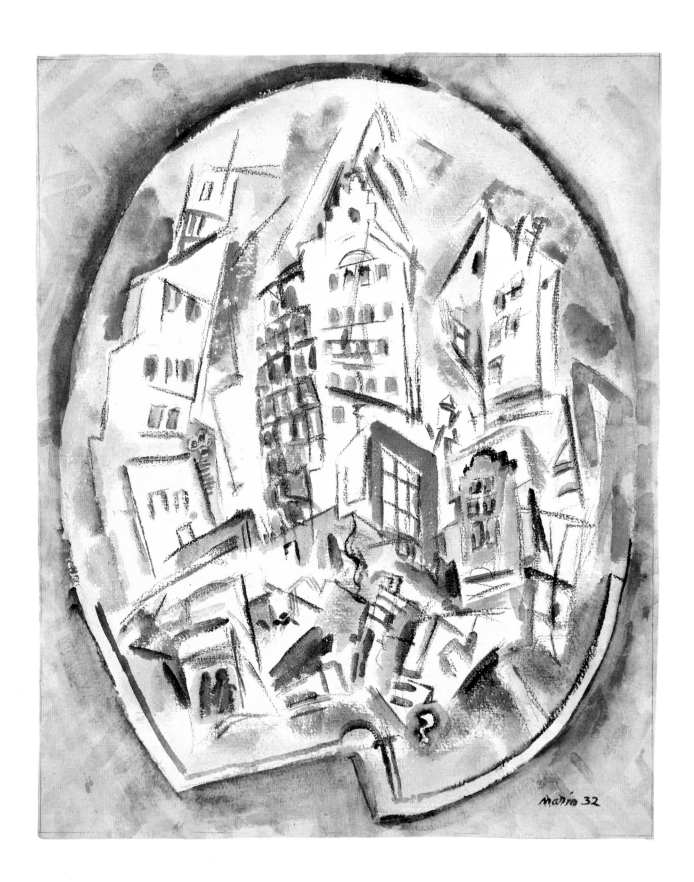

PABLO PICASSO
Spanish, 1881–1973

Cortège, 1933

While vacationing at Cannes in July of 1933, Pablo Picasso produced two drawings on a bacchanalian theme.[1] One of these, *Cortège*, depicts four figures carousing on a beach before a wide expanse of sea. A. Conger Goodyear, a former owner of the watercolor, recalled a conversation in which Picasso related the source of his inspiration:

When I bought this drawing Picasso was in the Galerie and I asked him about it. He said that he was in Marseilles and saw two sailors and a woman—all drunk reeling down the street led by a small child—and he made this drawing from that incident.[2]

In *Cortège* Picasso transforms an actual event into a myth of his own making, the drunken sailors of Marseilles becoming nude revelers from a classical past. The figures are all familiar Picasso characters. The fat, Silenus-like man and his bearded companion, for example, resemble the classical sculptor of the Vollard Suite, a series of prints completed by the artist in the 1930s. The woman also appears throughout the Suite as both model and lover to the artist, her profile and voluptuous body clearly that of Marie-Thérèse Walter, Picasso's young mistress and the inspiration for much of his art during the period.

The swirling forms and bold, sketchy style heighten the sense of a reeling, drunken procession. Light washes of watercolor appropriately define sea, air, and sand, while the face of the Silenus figure reflects the rosy tint of a drunkard. Even the eroticism of the scene is reinforced by the style, as the rounded forms of the woman's body are echoed in the cloud formations above. AC

1 The earlier work is a gouache of 6 July entitled *Silenus Dancing* (private collection, Switzerland) and features seven more clearly defined revelers; see William Rubin, ed., *Pablo Picasso: A Retrospective* (New York: Museum of Modern Art, 1980), p. 313.

2 Personal inventory files of A. Conger Goodyear, no. 612, Albright-Knox Art Gallery.

Pen and ink wash and watercolor
15¹³⁄₁₆ x 19¹⁵⁄₁₆ (40.5 x 50.7)
Inscribed lower left in ink: *Cannes 14 Juillet XXXIII Picasso*
Inv. no. 1970:2.24
Bequest of A. Conger Goodyear

Provenance: Galerie Simon, Paris; A. Conger Goodyear,
New York, 1935; bequest, 1970.

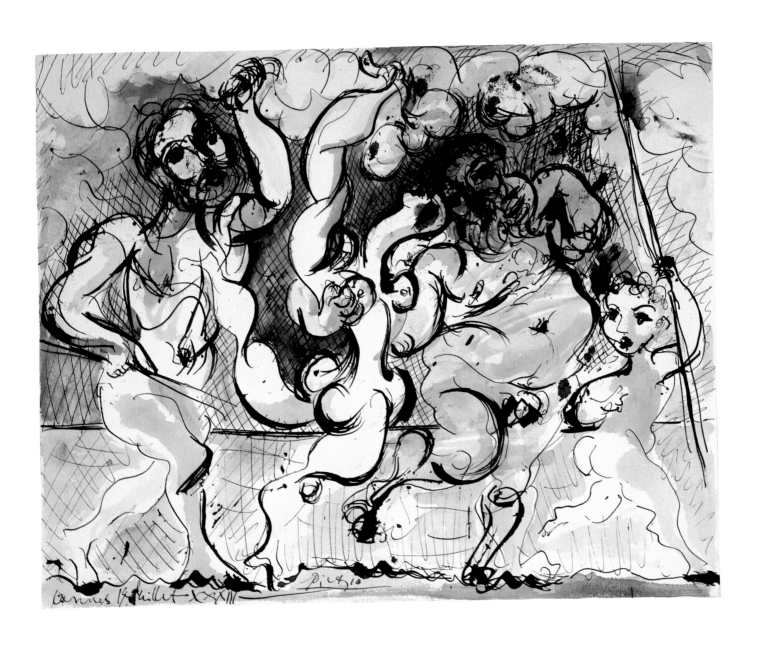

PAUL KLEE

Swiss, 1879–1940

Wehgeweihtes Kind (Child Consecrated to Suffering), 1935

The iconic quality of Paul Klee's *Wehgeweihtes Kind (Child Consecrated to Suffering)* inevitably evokes associations with primitive or non-European art. The artist's deep interest in primitive art is well documented and, indeed, pre-Columbian art offers the most convincing models for Klee's image and mode of representation in this work.[1] The linear construction, frontal view, and ceremonial headdress with its diamond pattern and dangling linear ornament all have antecedents in pre-Columbian art. More important, the image projects a timeless, universal presence that evokes ancient icons and stirs powerful emotions. Glowing earth tones, a moss-green patina, and a richly textured surface recall weathered bronze or stone idols. Form, features, and ornament are all rendered in an emphatically two-dimensional, linear style typical of the nonillusionistic traditions revered by Klee.

The close-cropped frontality and schematic features of the child suggest a ceremonial mask, yet the mask reveals rather than conceals the humanity within. It has been suggested that the poignant expression may reflect Klee's distress at the political upheavals of the period. A more personal reference may also be intended, for the first symptoms of Klee's fatal illness appeared sometime during 1935. Whatever the inspiration, the work is a powerful portrait of a loss of innocence, eloquently conveyed by a simple variation in the schema for the eyes. The heavy-lidded, downcast eye of sorrowful acceptance is offset by the arched lozenge of the other eye—an eye that marks the dawning of adult skepticism, perhaps even cynicism, in that traditional symbol of innocence, the child.[2] AC

[1] See Steven A. Nash, in Buffalo Fine Arts Academy, *Albright-Knox Art Gallery: Painting and Sculpture from Antiquity to 1942* (New York: Rizzoli International Publications in association with Albright-Knox Art Gallery, 1979), p. 383. Nash has suggested parallels with certain stone figures of central Mexico that date from the classic Teotihuacán period. James Smith Pierce (*Paul Klee and Primitive Art* [New York and London: Garland Publishing, 1976], p. 59) has singled out an image of a bronze disk from Masao-Chañaryaco, Argentina. Featuring a schematic, frontal face framed by a simple geometric headdress, the disk was reproduced in a 1930 issue of *Cahiers d'art* (vol. 5, no. 4), a magazine collected by Klee. The image of the child also recalls certain carved Mexican masks, many of which could have been seen in the Musée du Trocadéro, Paris; see Adolphe Basler and Ernest Brummer, *L'Art précolombien* (Paris: Librairie de France, 1928), pls. 42–64.

[2] The *W* that creases the child's brow forms a pun in conjunction with the inscription ("W = geweihtes Kind"), since in German the letter *W* and the word "weh" ("suffering") are pronounced alike (Nash, in Buffalo Fine Arts Academy, *Albright-Knox Art Gallery*, p. 383).

Oil and watercolor
6¼ x 9⅜ (16 x 23.9)
Inscribed on mount lower left in ink: *1935 K 11*; lower left in pencil:
III; lower right in ink: *W = geweihtes Kind*
Inv. no. RCA 1940:11
Room of Contemporary Art Fund

Provenance: Nierendorf Gallery, New York; purchased, 1940.

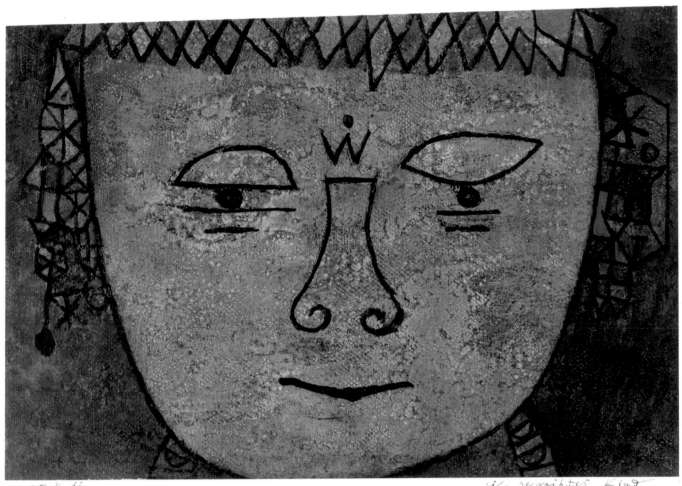

1935 K 11
III

JOAN MIRO

Spanish, 1893–1983

Femme assise (Seated Woman), 1935

*F*emme assise *(Seated Woman)* is one of about fifty small works executed in gouache by Joan Miró during the summer of 1935. Characteristic of Miró's works of the mid-1930s, it reflects the artist's growing anguish over the political turmoil in his homeland with the approach of civil war. Called by Miró *tableaux sauvages* (savage paintings), the works of the period are marked by exaggerated forms and brilliant colors.

Despite monstrous distortions of form, the woman of *Femme assise* is an elegant figure. The graceful lines that define her, particularly the mantilla-like curve of her upswept hair, suggest that the artist found his inspiration in traditional portraits of Spanish aristocrats. Posed in a conventional manner—except for her alarmingly upraised arms—this hybrid figure is all the more shocking because of her genteel associations. Her brow deeply furrowed and her gaze expressing ineffable sorrow, she seems to recoil in terror. That her horror is shared by Miró is suggested by his signature floating freely below the woman's open mouth as if in some magical invocation of the artist himself.[1]

Rich washes of fiery red and yellow—the colors of the Spanish flag—dominate the upper reaches of the work, while dark splashes of blue and black explode across the sheet. The precise, deeply inscribed contours and the flat, opaque colors of the woman and her chair offer a stunning contrast to this glowing, turbulent backdrop with its suggestion of infinite depth and violent conflict. The breathtaking beauty of its vibrant colors and the compelling horror of its misshapen forms make *Femme assise* a haunting portrait of impending tragedy. AC

[1] For a discussion of the mystical properties of names and words in primitive art with regard to Miró's work, see Sidra Stich, *Joan Miró: The Development of a Sign Language* (St. Louis: Washington University Gallery of Art, 1980), p. 15ff.

Gouache and watercolor
14½ x 11⅜ (36.8 x 28.8)
Inscribed center right in watercolor: *Miró*; on verso upper center
in ink: *Joan Miró/ "Femme assise"/8/8/35*
Inv. no. 1966:9.12
Bequest of A. Conger Goodyear

Provenance: Pierre Matisse Gallery, New York; A. Conger Goodyear,
New York; bequest, 1966.

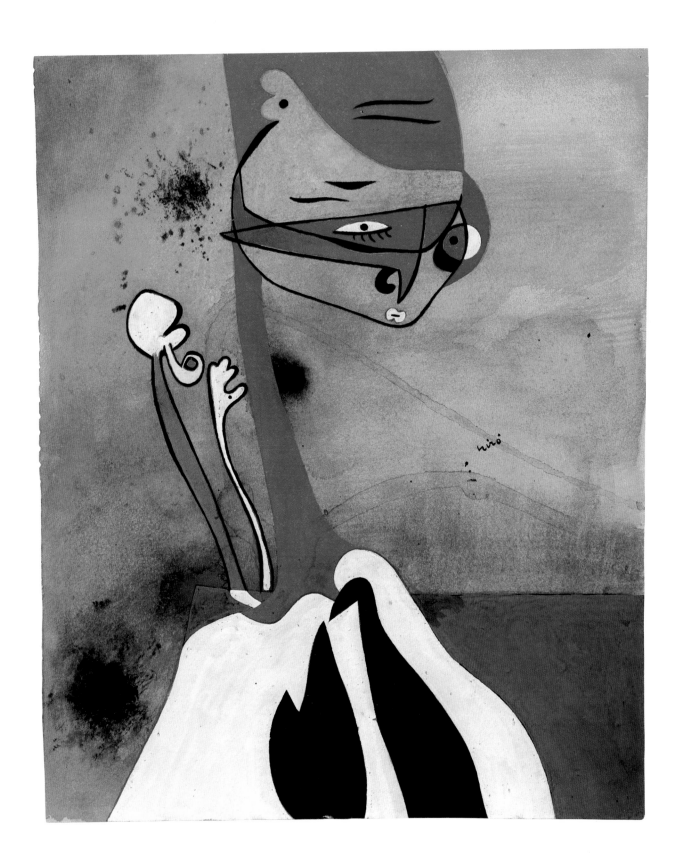

EMIL NOLDE

German, 1867–1956

Romantische Landschaft mit Burg (Romantic Landscape with Fortress),
c. 1941–45

Officially branded a "degenerate artist" by the Nazis, the German Expressionist Emil Nolde witnessed the confiscation of his works in the late 1930s. In 1941 he was forbidden to continue painting and responded by retiring to Seebüll, his home in northern Germany, where he secretly painted more than a thousand small, easily hidden works. Avoiding oils for fear the smell might betray his activity, Nolde turned to watercolor, a medium he had employed with great success in the past. Nolde called these works his *Ungemalte Bilder,* or unpainted pictures. Fully realized paintings, they are widely considered to be among his finest works.

Although depictions of the human figure predominate, there is an occasional landscape in the group. Like the other works of the period, *Romantische Landschaft mit Burg (Romantic Landscape with Fortress)* is painted on a small sheet of absorbent oriental paper, using an innovative watercolor technique developed by Nolde. Dampening the paper before applying pigment, he allowed the colors to flow together, permeating the paper. He controlled the movement of the colors with a wet brush or a piece of dry cotton wool, often allowing the resulting configuration to suggest further details of the composition.[1] After permitting the paper to dry, Nolde then painted over it to produce dense layers of luminous paint. Typically, no area of the paper is left untouched. A minimum of lines and touches of thick color define the details and rescue the work from abstraction.

Romantische Landschaft mit Burg depicts the northern German countryside that provided a refuge for Nolde in the 1940s. The fortress may, in fact, be an evocation of his home, Seebüll, which has been described as a citadel-like structure dominating the surrounding marshlands.[2] The work certainly reflects the artist's sense of isolation during this difficult period. AC

1 See Alfred Hentzen, in *"Unpainted Pictures": Emil Nolde 1867–1956* (New York: M. Knoedler & Co., 1966), pp. 17, 18. See also Peter Selz, *Emil Nolde* (New York: Museum of Modern Art, 1963), pp. 67, 70–71; and Alfred Werner, review of *Emile Nolde Landscapes: Watercolors and Drawings,* by Martin Urban, *Arts Magazine* 44, no. 7 (May 1970): 10.

2 Martin Urban, in *"Unpainted Pictures": Emil Nolde,* pp. 5–6.

Watercolor and ink on oriental paper
6⅞ x 7⅞ (17.4 x 20.1)
Inscribed upper right in ink: *Nolde*
Inv. no. 1965:6
Consolidated Purchase Funds

Provenance: Estate of Ada and Emil Nolde, Seebüll, Germany;
M. Knoedler & Co., New York; purchased, 1965.

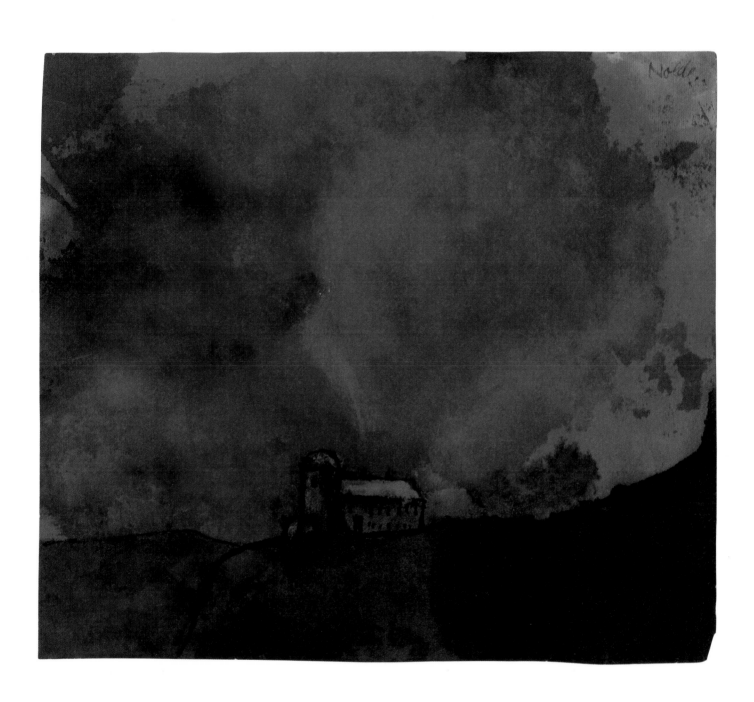

KURT SCHWITTERS

German, 1887–1948

Difficult, 1942–43

Forced to flee his native Germany in 1937, Kurt Schwitters settled in England in 1940 and continued to work in exile, producing a large number of collages. One of these, *Difficult*, was executed in London and seems to reflect the artist's response to his environment. The clipping that provides the title of the work was perhaps chosen to serve as a commentary on Schwitters's life in England. The airplane, the tires, and the headless woman with the electric pistol might be references to war, while other elements suggest details of daily life: bus tickets, wedding announcements, candy wrappers, and headlines and advertisements trumpeting domestic needs. Fragments pertaining to the world of art are more personal references. Whimsical touches, such as the chocolate wrapper cut to form a woman's coiffure, reveal Schwitters's celebrated sense of humor, active even in adversity.

Based on the repetition of a few basic shapes, the composition of *Difficult* has a dynamic directional movement. Splaying out along a central axis, the components form an inverted cone. The tire creates the illusion of an opening to create a funnel-like effect. The miniature triangles covering the "Pascall" tissue echo the shape of the overall composition, while the circular form of the tire is continually repeated in other objects, such as the chocolate wrappers, ticket holes, letters, and numbers. Otherwise, rectangular fragments predominate, their diagonal placement in this large collage giving an expansive, outward thrust to the composition.

The complexity of *Difficult* is central to its charm. The varied bits of English detritus that cover its surface fascinate not only because of the suggestive mystery of their identities but also because of the rich variety of their textures. AC

Collage
31¼ x 24 (79.4 x 61)
Not inscribed
Inv. no. K1965:14
Gift of Seymour H. Knox

Provenance: Estate of the artist; Marlborough-Gerson Gallery, New York; Seymour H. Knox, Buffalo, 1965; presented, 1965.

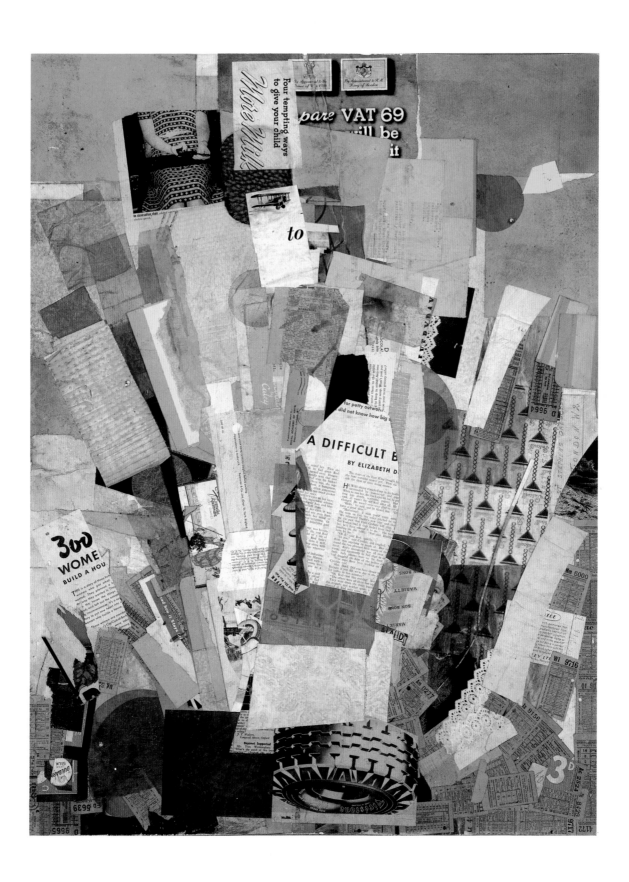

ARSHILE GORKY
American, born Armenia, 1904–1948

Abstract Forms, 1931–32

In 1931–32 Arshile Gorky completed numerous drawings in ink using both pen and brush, of which *Abstract Forms* is typical. They relate to specific works, but their significance exceeds their purpose; in these ink drawings, Gorky realized the basic structures and abstract forms of the personal iconography that would influence his mature work of a decade later.[1]

Abstract Forms is one of several drawings related to the theme Gorky termed "Nighttime, Enigma, and Nostalgia," executed as an oil painting of the same title in 1933–34 (private collection). Gorky's strenuous study of the modern masters, specifically Pablo Picasso and Joan Miró, is seen in the curvilinear abstract shapes that occupy distinct compartments in the drawing, the largest section of which is incorporated in the oil painting. A variation of the composition, including the palettelike form and the winding fish skeleton, makes up a portion of a plan for an ambitious but unrealized mural.[2] In these works a personal imagery evolved revealing abstract "Cubist" motifs and extraordinary still lifes and interiors influenced by Surrealism.

Gorky's skillful mastery of line is evident in his definition of elaborate shapes through cross-hatching and opaque washes. At the same time, he is able to evoke a mood of uncertainty and mystery through darkened forms. Despite the casual appearance of the work, which results from stray marks of smudged ink that reveal Gorky's working process, the artist's concept remains clear and powerful.

The role of drawing, and especially line, became increasingly significant in Gorky's work. In 1946 the critic Clement Greenberg, who championed the New York School, described Gorky's draftsmanship as "his most powerful and original instrument" and referred to his paintings as "essentially tinted drawings—which does not make them any less important."[3] Not only a major force in the development of Abstract Expressionism, Gorky was also one of this century's finest draftsmen. CB

[1] Brooks Joyner, *The Drawings of Arshile Gorky* (College Park: University of Maryland Art Gallery, 1969), p. 11.

[2] Two studies for the unrealized mural are reproduced in Diane Waldman, *Arshile Gorky 1904–1948: A Retrospective* (New York: Harry N. Abrams and Solomon R. Guggenheim Museum, 1981), nos. 50, 51.

[3] Cited in Joyner, *Drawings of Arshile Gorky,* p. 15.

Pen and ink wash
22¾ x 29⅛ (58 x 74)
Not inscribed
Inv. no. 1974:8.9
**Gift of Mr. and Mrs. David K. Anderson to
The Martha Jackson Collection**

Provenance: Martha Jackson Gallery, New York, 1962; David K. Anderson, Buffalo; presented by Mr. and Mrs. David K. Anderson to The Martha Jackson Collection, 1974.

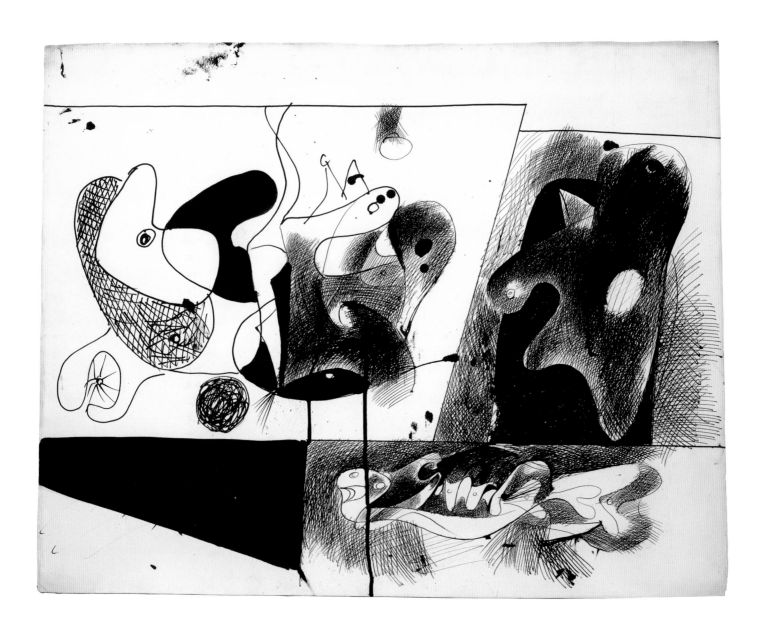

ROBERT MOTHERWELL
American, born 1915

Untitled, 1944

Robert Motherwell's abstractions of the 1940s were greatly influenced by the celebrated Surrealist technique of automatism, which encouraged the artist's interest in the visual realization of the subconscious. Motherwell recognized the significance of automatism in his work "as a plastic weapon with which to invent new forms" and as "one of the twentieth century's greatest formal inventions."[1] He eventually combined the spontaneity of this technique with conscious decisions during the creative process, and the resulting compositions are more formally designed, like this untitled work in the Gallery's collection. The role of intuition and emotion are critical to the evolution of Motherwell's oeuvre and became primary subjects in his later works.

The Gallery's drawing is reminiscent of works of the 1930s by Pablo Picasso and Joan Miró.[2] The directness of the composition is enhanced by the artist's use of pen and ink to create sharply outlined forms that contrast with the surrounding wash. A similar untitled composition of 1944 rendered by the artist in the same media (Philadelphia Museum of Art) includes a text in French that encourages a narrative interpretation. In both works, oval and rectilinear shapes clearly define male and female figures. In the Gallery's drawing, a narrative of conflict is suggested by their arrangement, the "female" turned away from the "male" and the two divided by a threatening barrier shaped like a head.

In contrast to the simplicity of materials employed in this work, Motherwell was at this time also creating richly textured collages that were autobiographical.[3] Within just a few years, the ovoid and rectilinear shapes of his seminal and monumental "Elegy" paintings, only hinted at in the Gallery's drawing, would be realized. CB

1 Betsy Severance and Anne Ayres, in *The Interpretive Link* (Newport Harbor, Calif.: Newport Harbor Art Museum, 1986), p. 128.

2 Jack D. Flam, *Robert Motherwell Drawings* (Houston: Janie C. Lee Gallery, 1979), sec. 3.

3 Ibid., sec. 4.

Pen and ink and watercolor wash
19 x 24⅝ (48.3 x 62.5)
Inscribed upper left in ink: *Robert Motherwell 1944*
Inv. no. 1974:8.23
**Gift of Mr. and Mrs. David K. Anderson to
The Martha Jackson Collection**

Provenance: David Anderson Gallery, New York; David K. Anderson, Buffalo; presented by Mr. and Mrs. David K. Anderson to The Martha Jackson Collection, 1974.

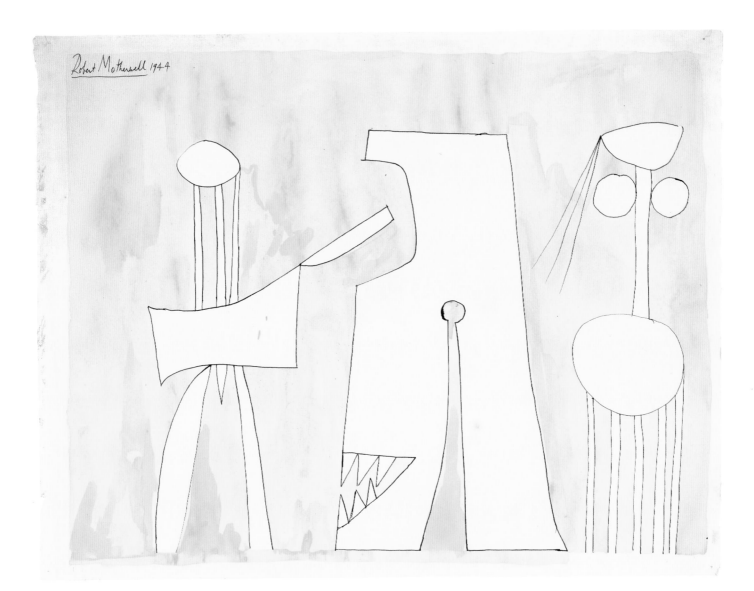

Robert Motherwell 1944

ANDRE MASSON
French, born 1896

Contemplation de l'abîme (Contemplation of the Abyss), 1944

In late 1943 André Masson embarked on a series of portraits of himself and his family. The self-portraits evolved into a distinctive series of profiled heads, most bearing the same title as the Gallery's drawing *Contemplation de l'abîme (Contemplation of the Abyss)*. Concurrently with the "Abyss" works, Masson did portraits of his wife, Rose, which the artist developed into a similar series of profiles called "Sibyls." Although the two series are close in form, composition, and mood, the self-portraits are distinguished by the presence of a floating, embryonic form.[1]

Masson's preoccupation in 1944 and 1945 with the theme of the artist contemplating weighty philosophical matters may reflect his anxiety over the war that had driven him into exile in America. Settling in the Connecticut countryside in 1941, Masson had found new inspiration in his surroundings. A favorite theme of the period for Masson was the concept of germination and the generative powers of nature. Myriad forms suggestive of gestational stages of development invade his work, providing clear prototypes for the embryonic form in the "Abyss" series. The generative associations of the form contribute an element of hope and wonder to the introspective mood of the Gallery's drawing—from the depths of the abyss comes a life-affirming vision for the artist.[2]

Separated from the object of his contemplation by a deep, velvety blackness eloquently suggestive of infinite depths, the image of the artist is rendered in a free, calligraphic line that recalls Masson's experiments in automatic drawing during the 1920s. Varying freely in width and direction, the expressive line reflects as well the profound influence of oriental art on his work in the 1940s.[3] Contrasting vividly with the crisp, black lines are softly blended modulations of grays and blacks. Subtle textural nuances, such as the linear scrapings that expose the paper, further enhance this contemplative work. AC

1 For a discussion of the history and symbolism of both series, see Carolyn Lanchner, "André Masson: Origins and Development," in William Rubin and Carolyn Lanchner, *André Masson* (New York: Museum of Modern Art, 1976), pp. 171–74.

2 Lanchner (ibid., pp. 172–73) suggests that the embryonic image may signify despair over the recurring cycle of destruction and regeneration. Her alternate interpretation of the abyss as a metaphor for the unconscious in Masson's art also has relevance for the series.

3 In late 1942 Masson was deeply influenced by his exposure to the collection of Asiatic art at the Museum of Fine Arts, Boston (ibid., p. 185).

Ink and charcoal on blue paper [faded]
24 x 18 (61 x 45.7)
Inscribed lower right in ink: *André Masson*
Inv. no. RCA 1944:13
Room of Contemporary Art Fund

Provenance: Buchholz Gallery, New York; purchased, 1944.

MARK TOBEY
American, 1890–1976

Red Man, White Man, Black Man, 1945

Mark Tobey initially received recognition as an illustrator and portraitist. A one-artist exhibition of his figurative work in 1917 at M. Knoedler & Co. in New York signaled the beginning of his professional recognition as an artist. His interest in form remained constant, even when undetected in his mature abstract paintings such as *Red Man, White Man, Black Man.* Recognized as the originator of the Northwest School of painting,[1] Tobey had a linear, calligraphic style that resulted from an integration of Eastern and Western stylistic influences. Integral to the evolution of his artwork was the artist's devotion to the Bahai World Faith, which emphasizes universal harmony—a theme Tobey visualized in his overall abstractions.

Following visits to China and Japan and a residence in New York, Tobey settled in London in 1935 and began to compose works that visualized his "desire to break and disintegrate forms and to use light structures rather than dark."[2] The evolution of what became known as his "white writing," Tobey stated, came from his need to "paint the frenetic rhythms of the modern city. . . . Through the traditional calligraphic line I was able to catch the restless pulse of our cities today."[3] Tobey's overall abstractions are formally comparable to the efforts of the New York School in that they extend a traditional method and yet allow the viewer to recognize the relationship of individual parts within the whole. By the mid-1940s, the time of this work, identifiable forms and a central focal point were nonexistent. Maintaining a muted, almost monochromatic palette enabled the artist to concentrate on the integration of forms within the entire composition. **CB**

1 William C. Seitz, *Mark Tobey* (New York: Museum of Modern Art, 1962), p. 53.

2 Ibid.

3 Eliza E. Rathbone, *Mark Tobey: City Paintings* (Washington, D.C.: National Gallery of Art, 1984), p. 20.

Oil and gouache on paperboard
25 x 28 (63.5 x 71.1)
Inscribed lower right in watercolor: *Tobey/45*
Inv. no. RCA 1946:4
Room of Contemporary Art Fund

Provenance: Willard Gallery, New York; purchased, 1946.

HENRY MOORE

British, 1898–1986

Reclining Figure with Pink Rocks, 1942

Throughout Henry Moore's career, drawing played an essential role in the development of his sculptural ideas. *Reclining Figure with Pink Rocks* anticipates the large elm sculpture *Reclining Figure* (Cranbrook Academy of Art, Bloomfield Hills, Michigan), on which Moore worked from 1945 to 1946. The fourth and largest of the preliminary studies for the sculpture, this drawing stands somewhat apart from the rest. With its fully modeled figure set into a surreal landscape, it is also a finished work of art in itself.[1]

In *Reclining Figure with Pink Rocks* the artist unites sculptural concepts and natural elements in a manner comparable to the way in which he combines the human figure with objects such as bones, rocks, or shells in a single sculpture. The flesh-toned rocks in the background recall bones and even vaguely foreshadow Moore's later two-part sculptures of reclining figures. In turn, the figure in the foreground appears ossified.

Moore intentionally sought this effect in his works because he believed that the design of a sculpture should acknowledge and complement the nature of the material from which it was made. It would be false, he felt, to try to imitate human flesh in stone or wood. Instead, he interpreted human form in terms of the static yet vital forms of mountains, crystals, tree roots, and other inanimate natural objects.

Color, absent from his sculpture, is subtle but central to Moore's drawing: light rose and yellow tints attract the eye and help to define form. As in many of his drawings from the 1930s on, Moore here used wax crayon and wash in an innovative manner. The crayon catches on the paper's rough tooth; the wash, repelled by the wax, retreats into the tiny fissures in the grain, resulting in a nubby-looking surface appropriate to the tactile sensibility of a sculptor. **HR**

1 *Reclining Figure with Pink Rocks* relates closely to two other 1942 drawings of sculpture in landscape: *Reclining Figure and Red Rocks* (British Museum, London) and *Wood Sculpture in Setting of Red Rocks* (Museum of Modern Art, New York); see Alan G. Wilkinson, *The Drawings of Henry Moore* (London: Tate Gallery in collaboration with Art Gallery of Ontario, 1977), pp. 41, 121.

Pen and ink and watercolor over wax crayon
22 x 16⅝ (56 x 42)
Inscribed lower left in ink: *Moore/42*; on verso center in pencil:
RECLINING FIGURE WITH PINK ROCKS/1942
Inv. no. RCA 1943:13
Room of Contemporary Art Fund

Provenance: From the artist to Buchholz Gallery, New York, c. 1943;
purchased, 1943.

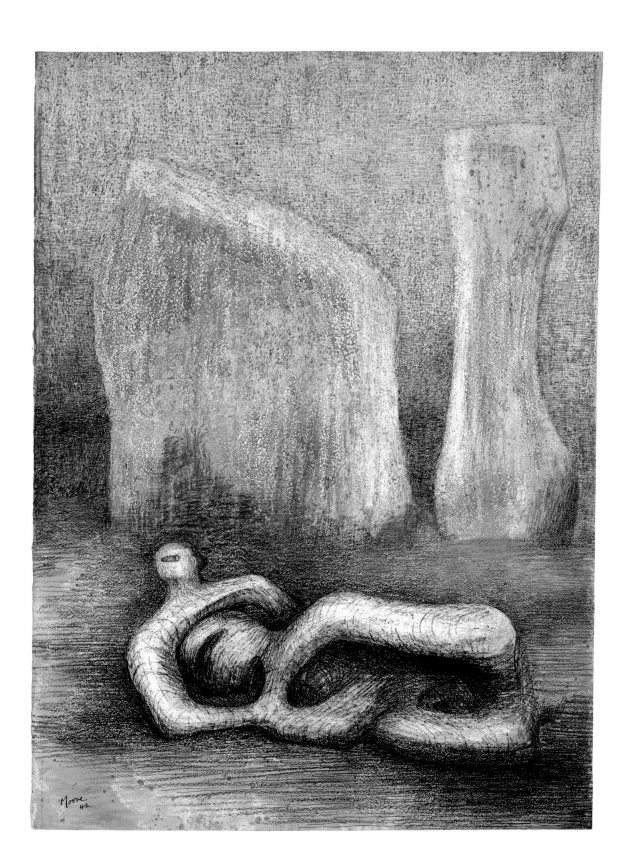

MORRIS GRAVES

American, born 1910

Black Waves, **1944**

Morris Graves reluctantly allowed Dorothy Miller to include nearly thirty of his paintings in the Museum of Modern Art's exhibition *Americans 1942: Eighteen Artists from Nine States*, one in the renowned series devoted to highlighting contemporary art in this country. This first extensive public exposure of the artist's work outside of his native Pacific Northwest received overwhelming praise. In the accompanying catalogue, Graves stated his objectives:

> I paint to evolve a changing language of symbols, a language with which to remark upon the qualities of our mysterious capacities which direct us toward ultimate reality.
>
> I paint to rest from the phenomena of the external world—to pronounce it—and to make notations of its essences with which to verify the inner eye.[1]

First described by critics as surreal,[2] Graves's delicately rendered, haunting images are based on natural forms, often birds of various types placed against dark, ominous grounds and defined or entangled by calligraphic "white writing." Graves imbues his compositions with a mysterious and boundless intensity, like that found in *Black Waves*.

Apparent in his works is an affinity for Asian, particularly Japanese, art. As a young man, Graves was a merchant seaman and visited Japan frequently. Its culture profoundly influenced his life although he did not return to that country until decades later. The effect of Japanese art was perhaps most strongly felt in his work of the early 1940s, when *Black Waves* was completed.[3] Stemming directly from Graves's painting *Sea and Morning Redness*, 1944,[4] *Black Waves* symbolizes the emotional trauma of the world during this period of history and the deeply ominous feelings Graves experienced as a result.

In this work, Graves rendered a turbulent sea with assured strokes of paint that are unexpectedly delicate. By crumpling the textured paper, Graves increased the dramatic, three-dimensional effect of the raging sea he painted. Because he heavily saturated the support with dark color—which was at one time indigo blue[5]—the contrasting strokes of white defining sea and sky take on a special brilliance. The constellation Graves includes is composed of simple lines and dots yet, because of its placement, is as prominent as the dynamic waves and may represent an expression of hope. **CB**

1 *Americans 1942: Eighteen Artists from Nine States*, ed. by Dorothy C. Miller, with statements by the artists (New York: Museum of Modern Art, 1942), p. 51.

2 Ray Kass, *Morris Graves: Visions of the Inner Eye* (New York: George Braziller in association with the Phillips Collection, 1983), p. 32.

3 *The Drawings of Morris Graves* (Boston: New York Graphic Society in association with the Drawing Society, 1974), p. 54.

4 Ibid., p. 72. The work is in the collection of the Art Institute of Chicago, gift of Mr. and Mrs. Howard G. Kornblith as a memorial to their daughter, Suzanne, 1951.223.

5 Condition Report, Intermuseum Laboratory, Oberlin, Ohio, 1984, in the Gallery files.

Synthetic dye (originally blue indigo) and gouache (and possibly dirt)
27 x 53½ (68.6 x 135.9)
Not inscribed
Inv. no. RCA 1944:20
Room of Contemporary Art Fund

Provenance: From the artist to Willard Gallery, New York, 1944;
purchased, 1944.

CHARLES BURCHFIELD
American, 1893–1967

Mid-June, 1917–44

Throughout most of his career, Charles Burchfield concentrated on an empathetic depiction of everyday urban scenes typical of northern industrial cities, including Buffalo. With the consummate skill and confidence developed through nearly thirty years of painting, Burchfield turned to his early works for inspiration. Their spontaneity and whimsy stimulated his paintings of the 1940s, including a series of "reconstructions" or extensions of earlier works, of which *Mid-June* is an example.

Mid-June is a frenetic expression of summer and, as in other "reconstructions," the visual depiction of motion is a dominant theme. "I realize that there is nothing so original about this, as others have made similar experiments (notably the nude descending a staircase)," Burchfield stated.[1] As in other compositions in this series, a central passage is from an earlier watercolor; in this case, the trunk of the large maple and three pine trees to the left of it were painted in 1917.

The artist wrote this lively explanation of *Mid-June* following its acquisition by the Gallery:

It is a hot humid day, close to the time of the summer solstice, when the sun at noon seems to be almost directly overhead. . . . In the foreground is a maple tree, whose umbrella-like canopy of drooping leaves . . . casts its circular shadow on the earth, forming a sort of cone of shade, surrounded by sunlight. . . . Great tiger swallow-tail butterflies, characteristic creatures of June, are disporting themselves. . . . Out and down they flutter in nervous restless flight, only pausing momentarily to rest on some convenient mandrake leaf. At times they quarrel and the skirmish presents to the eye a bewildering clash of yellow and black rhythms. Then constant motion seems to set the trees to dancing. . . . Creatures and plants seem to be intoxicated by the sheer ecstasy of existence on such a day.[2] CB

1 John I. H. Bauer, *The Inlander: Life and Work of Charles Burchfield, 1893–1967* (Cranbury, N.J.: Associated University Presses and Cornwall Books, 1982), p. 37.

2 Letter from the artist to Albright-Knox Art Gallery, 14 May 1946, in the Gallery files.

Watercolor on pieced paper mounted on Masonite
36 x 48 (91.4 x 121.9)
Inscribed lower right in watercolor: monogram of artist/*1917–44*;
on verso center in pencil: *June 10, 1917*
Inv. no. 1946:1
Charles W. Goodyear Fund

Provenance: From the artist to Frank K. M. Rehn Gallery,
New York, 1944; purchased, 1946.

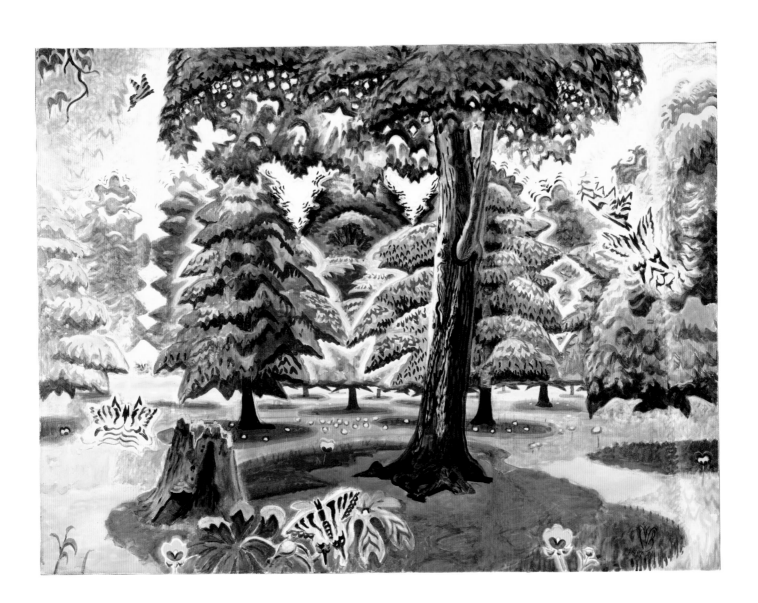

REGINALD MARSH

American, 1898–1954

Swimming off West Washington Market, 1940

From the Bowery to Fourteenth Street to Coney Island, Reginald Marsh haunted New York during the 1930s and 1940s, incessantly sketching the scenes that would fill his paintings. Like many of his popular and enduring works of the period, *Swimming off West Washington Market* depicts the public diversions of New York's masses. Marsh described the work in a letter to the Gallery in 1945:

The scene shows one of the last "swimming holes" in the Hudson, 1939—stopped thereafter by the war. The docks were old and about the only surviving open piers for family swimming and loafing bums, both kinds of people shown in the picture. The scene contains many of the things I like to paint—viz: girls, bums, athletes, muscles, tugs, and ocean liners, clouds and waves, movement, all in one. I swam myself here all that summer and did a bit of looking.[1]

Rejecting abstraction, Marsh turned to the Old Masters for inspiration, finding models for his heavily muscled men and voluptuous women in the works of Michelangelo, Rubens, and Delacroix.[2] In its concern with the public display of the human body, *Swimming off West Washington Market* is reminiscent of Marsh's many depictions of bathers crowding the beaches of Coney Island. Marsh delights in the sexual innuendo implicit in a milling throng of tangled, nearly naked bodies. Choppy, broken contours and restless, interlocking rhythms emphasize the swelling forms of those bodies and create a sensation of flickering movement as the figures are compressed into a shallow, friezelike space in the foreground.

Essentially a draftsman, Marsh favored media that would complement his graphic skill. He painted about forty large, highly finished watercolors in 1939–40, including this painting in the Gallery collection, according them a scale and importance usually reserved for oil paintings. Although secondary to line, color is skillfully employed in the work. Predominantly gray and sepia, color unifies this busy composition and underscores its concerns with the isolation of the individual within a group. AC

1 Letter from the artist to Albright-Knox Art Gallery, 29 Jan. 1945, in the Gallery files.

2 See Marilyn Cohen, *Reginald Marsh's New York* (New York: Whitney Museum of American Art in association with Dover Publications, 1983), p. 21.

Watercolor

26¾ x 40¼ (68 x 102.3)

Inscribed lower right in watercolor: REGINALD MARSH 1940

Inv. no. RCA 1944:18

Room of Contemporary Art Fund

Provenance: Frank K. M. Rehn Gallery, New York; purchased, 1944.

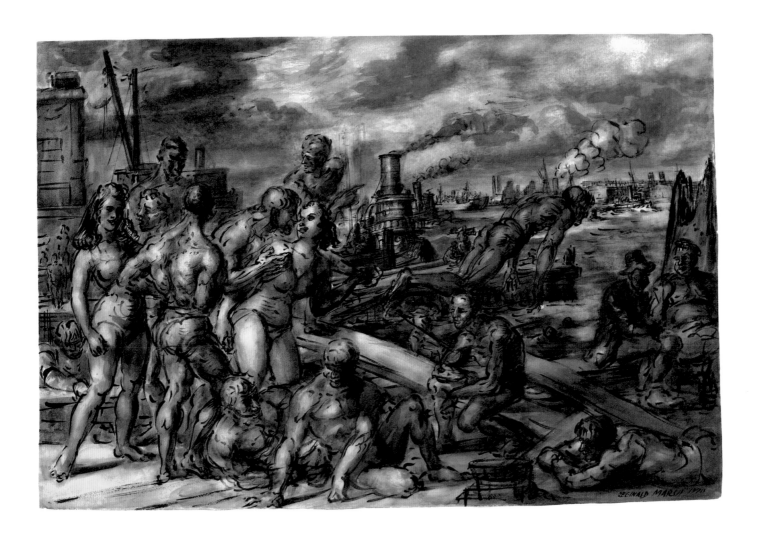

GRAHAM SUTHERLAND
British, 1903–1980

Thorn Trees, **1946**

The dramatic landscape of Pembrokeshire, Wales, which Graham Sutherland first visited in 1934, was to provide the artist with his greatest inspiration. His successful career as a printmaker was cut short by the Wall Street crash of 1929; forced to work as a commercial artist, he began in the early 1930s to explore painting in watercolor and in oil. It was not until his travels led him to Pembrokeshire, however, that he realized the direction of his work. He stated:

It was in this area that I learned landscape was not necessarily scenic, but that its parts have an individual figurative detachment. . . . The clear, yet intricate constructions of the landscape, . . . coupled with an emotional feeling of being on the brink of some drama, taught me a lesson and had an unmistakable message that has influenced me profoundly.[1]

Sutherland completed numerous works based on the exotic terrain of Pembrokeshire, including preliminary studies and a series of four oil paintings entitled *Thorn Trees*, of which the Gallery owns the fourth version. Dating from 1945–46, the series evolved during Sutherland's consideration of his first commission to do a religious subject, a crucifixion for Saint Matthew's Church in Northampton, which he completed in 1946:

I was, in connection with Northampton, thinking about making studies of a crown of thorns for the figure, and therefore had been observing closely the formation of real thorns. In Pembrokeshire where I was staying, the thorns are very convoluted and tortured and I began to see that these might form a basis of pictures in their own right, and without any connection with the crucifixion.[2]

Although this intimate watercolor closely resembles the canvas of the same title in the Gallery's collection, it is dated a year later. In a powerful study that belies its size, Sutherland has depicted a harsh reality: writhing thorns defined by pen and black ink pierce the air, surrounded by washes of blues and greens that, unlike those in the canvas, are oddly warm in tone. The grid that is lettered across the top and numbered down the sides orders the composition into details. Sutherland created additional canvases by repeating details from finished works, and it is possible that this watercolor served that purpose. The artist's fascination with the subject is evidenced by its appearance in later works. **CB**

1 Letter from the artist to Colin Anderson, in "Graham Sutherland: 'Welsh Sketch Book' "; reprinted in Ronald Alley, *Graham Sutherland* (London: Tate Gallery, 1982), pp. 25–26.
2 Letter from the artist to Albright-Knox Art Gallery, 26 Sept. 1968, in the Gallery files.

Pen and ink, watercolor, charcoal, and pencil
7⅞ x 7¾ (20 x 19.6)
Inscribed upper right in ink: *Sutherland/May 31st 46*
Inv. no. 1981:43
Bequest of Andrew C. Ritchie

Provenance: Andrew C. Ritchie, New Haven, Connecticut; bequest, 1981.

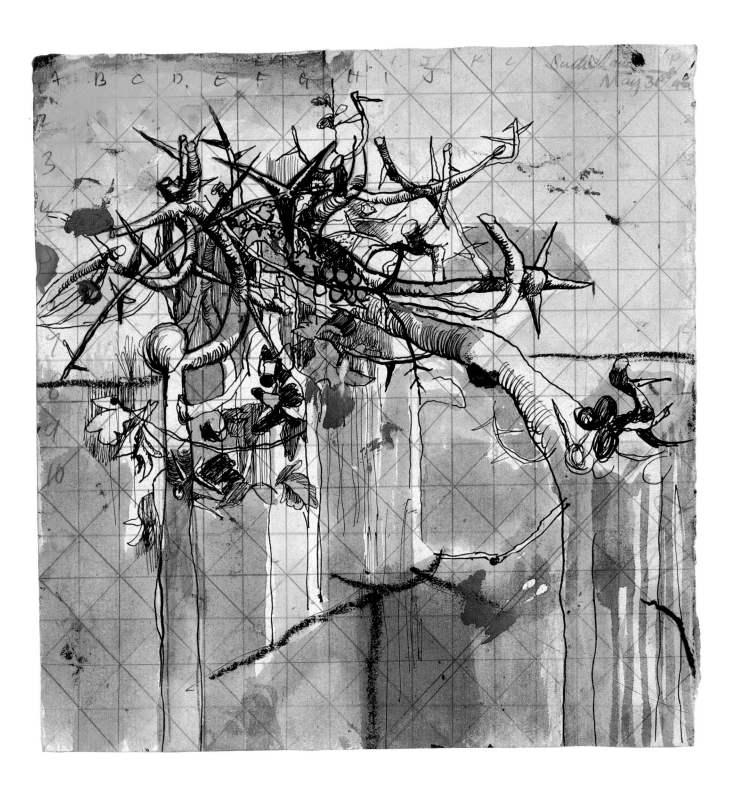

SAM FRANCIS
American, born 1923

Black Instant, 1958

In a review of an exhibition of Sam Francis's work in 1959, the art critic Dore Ashton remarked: "In the watercolors, the color interstices remain true, and they are helped by intermediary tones. . . . The floating, the falling, . . . the gratuitous meetings in space, the junctures and coincidences which Francis is best equipped to express are endowed with a magic in the watercolors."[1] *Black Instant* epitomizes the beauty and spontaneity that Ashton described. It is representative of a group of particularly successful watercolors that Francis executed in Paris in 1958 during a brief respite from world travels. Soon after his decision in 1950 to settle permanently in Paris, his work evolved from delicate, nearly colorless paintings to brightly keyed oils and watercolors. Although he had reintroduced color as early as 1952, it was not until 1954 that black began to play an important role, often acting like a screen—as in *Black Instant*—through which the color shines with jewel-like brilliance. He said of his method in oil: "I start by painting the entire canvas white. As other colors are added, it becomes less intense. I add black to bring back the intensity."[2] In works on paper he achieved the same effect simply by using the white of the paper, instead of paint, to provide an airy expanse in which his colors could float and spill. This white space became especially important in Francis's works of 1957 to 1959. *Black Instant*, with its shower of color descending toward a pristine void, reflects the upward compositional shift of gravity in his paintings of the period. **HR**

1 Dore Ashton, "Art," *Arts & Architecture* 761, no. 2 (Feb. 1959), p. 32.

2 Sam Francis, cited in Robert T. Buck, Jr., "The Paintings of Sam Francis," in *Sam Francis: Paintings 1947–1972* (Buffalo: Buffalo Fine Arts Academy, 1972), p. 19.

Gouache and watercolor on watercolor paper
22¼ x 29⅞ (56.7 x 75.9)
Inscribed on verso center left in crayon: *Sam Francis/58*
Inv. no. 1971:4.9
Gift of The Seymour H. Knox Foundation, Inc.

Provenance: From the artist to Martha Jackson Gallery, New York; Seymour H. Knox, Buffalo; presented, 1971.

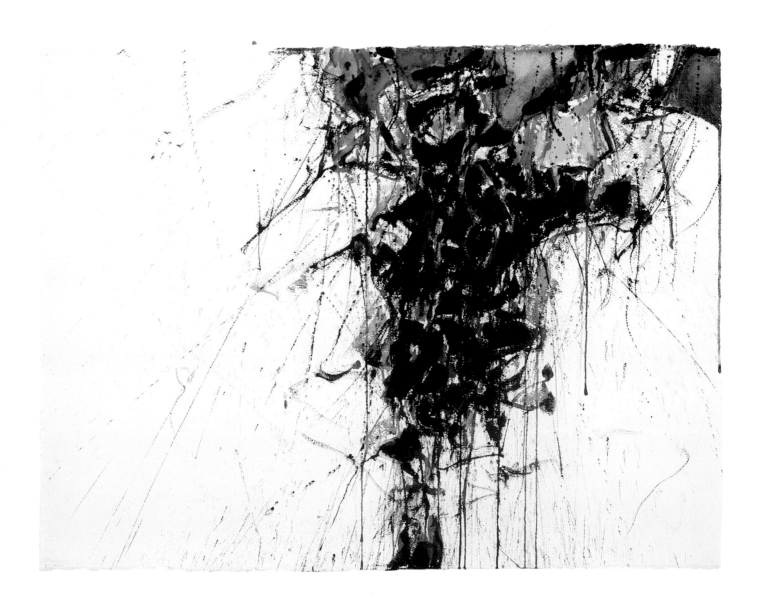

LARRY RIVERS
American, born 1923

Portrait of Martha Jackson, 1953

Larry Rivers drew this portrait of the art dealer Martha Jackson in 1953, the year she opened her first gallery in New York. The rare, warm personal rapport that she developed with the artists whom she represented led many of them, like Rivers, to make gifts of artwork for her. Jackson was among the first to promote the work of the Abstract Expressionists and later the Pop artists. Rivers's art falls between these two groups. In the face of predominating abstraction, he embraced figuration and initiated a dialogue, encompassing both homage and parody, with the work of the Old Masters. His art often includes images of the banal trappings of modern life, yet he has never presented them in the cool, commercial-looking style associated with Pop art.

Portrait of Martha Jackson demonstrates Rivers's adaptation of expressionist means to figurative ends. Marks that are simultaneously gestural and descriptive and traces of accident and erasure accumulate to form a sensitive likeness. His license in depicting Jackson's features affects the sense of character conveyed by the portrait. The sitter's widely spaced eyes and straightforward gaze, together with the delicate delineation of her nose and mouth, present the impression of an approachable person who is at once strong and vulnerable.

Drawing, for Rivers, forms the backbone of art; it "is the ability to use a line or mark to produce air, space, distinctions, peculiarities, endings, beginnings."[1] *Portrait of Martha Jackson* belongs to a series of drawings of friends that Rivers made in 1953, a year of transition for the artist. The previous year, he had done a number of violently expressionist figure drawings and paintings and worked on rough, abstract collages. In contrast, the 1953 drawings display the light touch, concise outlines, intuitive scribbles, omissions, and blurring that are characteristic of his mature style. **HR**

[1] Cited in Sam Hunter, *Larry Rivers* (New York: Harry N. Abrams, 1971), p. 22.

Pencil on paper
13⅞ x 16½ (35.2 x 42)
Inscribed lower right in pencil: *For Martha/It was 1953, Summer/Rivers*
Inv. no. 1974:8.32
Gift of Mr. and Mrs. David K. Anderson to
The Martha Jackson Collection

Provenance: From the artist to Martha Jackson, New York, 1961; Estate of Martha Jackson; presented by Mr. and Mrs. David K. Anderson from the Estate of Martha Jackson, 1974.

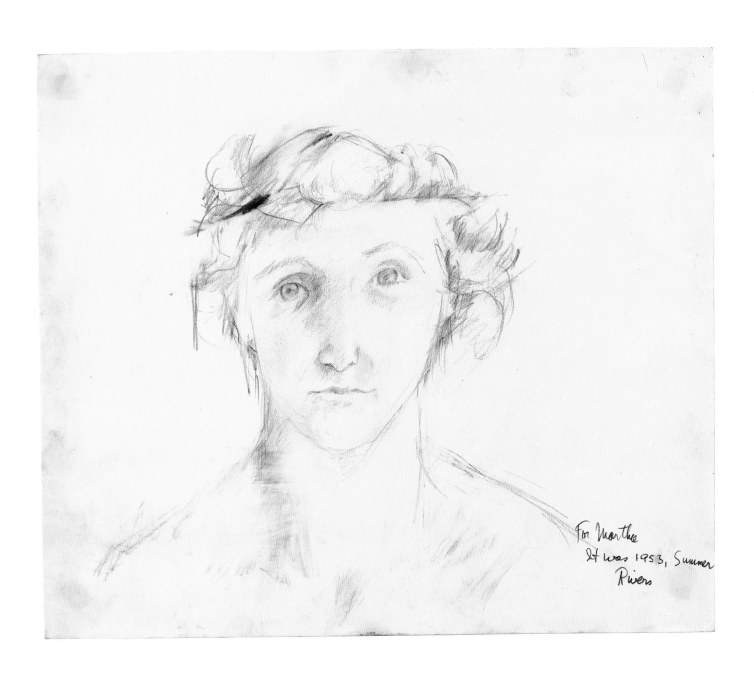

For Martha
It was 1953, Summer
Rivers

CLAES OLDENBURG
American, born Sweden 1929

Diagonal Girl against the Flag, 1960

A self-proclaimed "newspaper man" at heart, Claes Oldenburg approaches art as a kind of reporting: "I am for an art that takes its form from the lines of life itself, that twists and extends and accumulates and spits and drips, and is heavy and coarse and blunt and sweet and stupid as life itself."[1] In an exhibition titled "The Street" held at Judson Church Gallery, New York, early in 1960, he displayed drawings and constructions made of local rubbish that portrayed the down-at-the-heels yet lively ambience of the Lower East Side.

Diagonal Girl against the Flag, executed probably in the fall of 1960, represents a transition between the gritty neutral tones and coarse materials of Oldenburg's "Street" works and the colorful, more sensuous treatment of the items that he manufactured the following year for his installation "The Store." He had spent the intervening summer in Provincetown, Massachusetts, where he was inspired by the "commercialism of patriotism and history," as he put it, to make a series of works based on the American flag.[2] The inherent pattern and flexibility of the flag lent it readily to Oldenburg's manipulations; when he returned to the city, he began to move away from his previous style, distinguished by muted tones and nervous lines, and started to combine the flag with angular drawings of the street people who had populated his earlier creations. In some of these drawings, like *Diagonal Girl against the Flag*, he introduced bright colors.

Diagonal Girl against the Flag still displays some of the "ugliness" that Oldenburg sought in his "Street" works; its ragged images echo the contours of its torn paper edges. Yet the artist's acerbic wit, evident in the pairing of the symbol of America and a street person, is tempered by his enthusiastic embrace of life in all its aspects. Through his scrawling graffitilike line and almost violent splashes of color, he captures the vitality of his subject with all its contradictions. **HR**

1 Artist's statement in *Environments, Situations, Spaces* (New York: Martha Jackson Gallery, 1961); reprinted in *Claes Oldenburg* (London: Arts Council of Great Britain, 1970), p. 11.

2 Cited in Ellen H. Johnson, *Claes Oldenburg*, Penguin New Art 4 (Baltimore: Penguin Books, 1971), p. 16.

Watercolor, pastel, and pencil on torn paper
12¾ x 21¼ (32.5 x 54)
Inscribed lower right in pencil: *C 0/60*
Inv. no. 1974:8.26
**Gift of Mr. and Mrs. David K. Anderson to
The Martha Jackson Collection**

Provenance: From the artist to Martha Jackson, New York, 1961; Estate of Martha Jackson; presented by Mr. and Mrs. David K. Anderson from the Estate of Martha Jackson, 1974.

JAMES ROSENQUIST
American, born 1933

Rouge Pad, 1975

D rawing upon his experience as a billboard painter, James Rosenquist had evolved by the early 1960s a distinctive style based on commercial techniques, immense scale, and fragments of illusionistically rendered images. The 1970s, however, saw changes in Rosenquist's art that reflected events in his life. Finding himself deeply in debt and emotionally traumatized from an automobile accident in 1971, he turned to printmaking to supplement his income. Closely related to the prints of this period is a series of paintings on paper begun in early 1974. Considered experimental and transitional, the works are similar in execution to *Rouge Pad*, which is painted in acrylics and features a horizontal, tripartite composition and geometric shapes.[1]

Aligned in a row over a bright, acrylic-spattered surface that recalls the artist's formative years under the influence of Abstract Expressionism, the images are characteristically large and familiar: the rouge pad belongs to Rosenquist's long-established iconography of cosmetics; the dynamic spiral, which recalls the target paintings of Jasper Johns and Kenneth Noland, corresponds to numerous circular forms found in Rosenquist's prints of the 1970s; and the distinctive grouping of multicolored nails occurs in both his prints and paintings of the period.

Oddly juxtaposed, the images invite interpretation even as they resist it. Set in a splash of paint that suggests the spilled contents of a bottle of rouge, the cosmetic pad projects from the surface through a circular hole in the paper. It is covered with a soft, tinted cloth that seems to invite touching. A tangible, larger-than-life depiction of a woman's personal toilette, the image is disturbingly intimate.

The cosmetic associations continue in the thick stripes of vivid color that scream across the paper, spawning hands that lunge for the rouge pad. The relationship of the hands to the five painted nails beneath suggests an intentional pun on the elegant hands with perfectly manicured fingernails that appear so often in Rosenquist's early paintings. The allusion continues in the 1980s in works like *Fahrenheit 1982°*, in which bright enameled fingernails end in sharp, fountain-pen tips, shaped disconcertingly like the pointed nails of *Rouge Pad*.[2] AC

1 See Judith Goldman, *James Rosenquist* (New York: Viking Penguin and Denver Art Museum, 1985), p. 57.

2 Collection of Martin Z. Margulies, Miami; illustrated in ibid., p. 175. See also *While the Earth Revolves at Night*, 1982 (collection of Barry and Gail Berkus); illustrated in ibid., p. 176. Curiously, the fingertips in both works are superimposed over colored concentric lines that suggest the spiral of *Rouge Pad*. For additional interpretations of Rosenquist's nails, see ibid., pp. 56–57.

Acrylic paint and fabric
36¼ x 75 (92 x 190.5)
Inscribed lower left in pencil: *Rouge Pad*; lower right
in pencil: *James Rosenquist 1975*
Inv. no. 1975:14
National Endowment for the Arts Purchase Grant
and Matching Funds

Provenance: From the artist to Leo Castelli Gallery,
New York, 1975; purchased, 1975.

CY TWOMBLY
American, born 1927

Untitled, 1964

Drawing and writing are nearly indistinguishable in the work of Cy Twombly. Compositions on paper and on canvas are created by the artist's mixing of intimate gestures with a vocabulary of symbols that are personal and referential and, at the same time, indecipherable. His calligraphic style first evolved in the early 1950s, when the highly gestural canvases of his contemporaries predominated. In 1951 his persistent interest in the classical world led him to live for short periods in North Africa, Spain, and Italy; in 1957 he settled permanently in Rome.

Twombly's compositions appear to result from an almost unconscious, frenzied automatic writing that includes identifiable written references such as numbers and names. Typical of the artist's works of the early 1960s, the Gallery's untitled drawing is a seemingly unfinished composition that moves in several directions. One of a series of works that Twombly made in the Italian Alps in the summer of 1964, this drawing refers to his previous work and yet reflects his immediate environment. Maintaining a white support and the horizontal format of his landscapes, he used undulating, rhythmical pencil lines, reminiscent of graphic recordings of movement, to depict the peaked mountains surrounding him.[1] Additional marks, applied loosely and vigorously with graphite and colored pencils in layers, extend the image and make no reference to depth. Obscured by myriad marks over the center of the composition is a rectangular shape that was by this date a familiar element in Twombly's drawings, and which may represent a window. Numbers drift across the page appearing unexpectedly while others descend in sequence from the highest peak, paradoxically defining and measuring their descent. The artist's signature and the date of the work are so well integrated in the composition as to be nearly invisible. As in earlier works, the addition of sensuous rose and peach tones may be intended as erotic references. CB

[1] Suzanne Delehanty, *Cy Twombly: Paintings, Drawings, Constructions 1951-1974* (Philadelphia: Institute of Contemporary Art, 1975), p. 22.

Graphite, charcoal, colored pencils, and ball-point pen
27¾ x 39⅜ (70.3 x 100.1)
Inscribed upper right in pencil: *Cy Twombly Aug 1964*
Inv. no. 1980:46
Gift of Mr. and Mrs. Armand J. Castellani

Provenance: From the artist to Leo Castelli Gallery, New York; Sotheby Parke Bernet, New York, 1977; Armand J. Castellani, Niagara Falls, New York, 1977; presented by Mr. and Mrs. Armand J. Castellani, 1980.

MILTON AVERY

American, 1893–1965

Dark Trees, Pale Mountain, 1962

There is a profound sense of timelessness in the last works of Milton Avery, reflective not only of the evolution of his unfaltering vision but also of the artist's recognition of his own mortality. After suffering a second heart attack in 1960, Avery had to restrict his physical activity severely. He was able to resume travel in 1962 and, with his wife, Sally, visited Lake Hill, New York, the site depicted in this work. The landscape of this rural area—altered by light and weather—served as Avery's subject for a series of paintings on paper that, with the exception of only a few larger canvases, would be his last major work.

As in his most successful canvases, the elements of *Dark Trees, Pale Mountain* are pared down to their very essence. There is little to identify this landscape as a specific view or instance in time. The serene atmosphere of his earlier canvases, which he produced with passages of thinly applied paint, is gone, replaced by a sense of agitation achieved through the use of obvious brushstrokes and scratches to the surface. The physical limitations imposed on Avery by his failing health affected his choice of materials and resulted in his use of a smaller scale and of paper as a support. The decision to restrict himself to black and white in this later series may also be interpreted as a reflection of the artist's emotional state. Despite the limited palette, Avery's remarkable mastery of color is visible in the luminous quality of the grays in this monumental landscape. **CB**

Oil

23⅛ x 35¼ (58.7 x 89.4)

Inscribed lower left in pencil: *Milton Avery 1962*

Inv. no. 1985:15

Gift of Mr. and Mrs. Armand J. Castellani

Provenance: Estate of the artist; Marianne Friedland Gallery, Toronto, Canada, 1982; Armand J. Castellani, Niagara Falls, New York, 1982; presented by Mr. and Mrs. Armand J. Castellani, 1985.

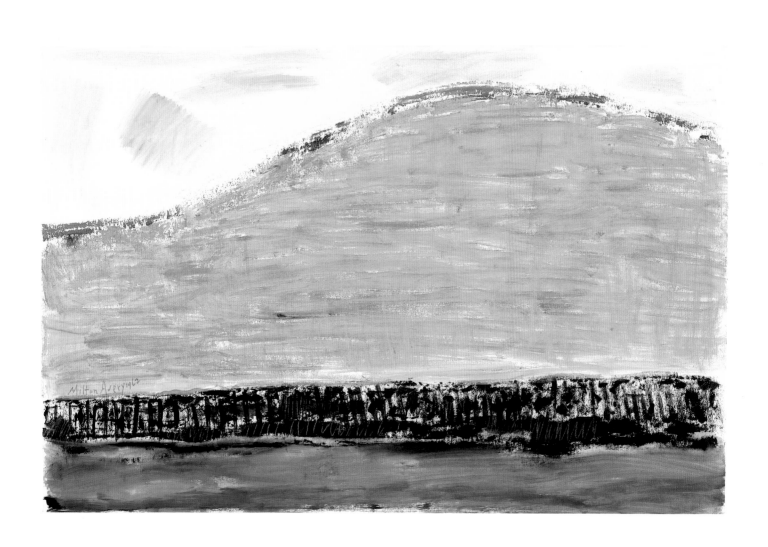

DAVID SMITH
American, 1906–1965

Untitled, 1963

Drawing was as significant a means of expression as sculpture for David Smith. A prolific draftsman, he revealed himself and his ideas about sculpture in countless works on paper throughout his career, yet rarely based a sculpture directly on one of them. Smith assessed the role of drawing in his oeuvre in 1953:

These drawings are studies for sculpture. Sometimes what sculpture is, sometimes what sculpture can never be. Sometimes they are atmospheres from which sculptured form is unconsciously selected during the labor process of producing form. Then again they may be amorphous floating direct statements in which I am the subject, and the drawing is the act. They are all statements of my identity and come from the constant workstream. I never intend a day to pass without asserting my identity, my work records my existence. My sculpture and especially my drawings relate to my past works, the three or four works in progress and to the visionary projection of what the next sculptures are to be.[1]

In the 1960s Smith conceived the "Cubi" series of sculptures, of which *Cubi XVI*, 1963, in the Gallery's collection is an example and to which this drawing is related. First inspired by stacking cardboard boxes atop one another, Smith concentrated on volumetric shapes rather than planar surfaces in the series. His renewed attention to landscape was evidenced in his desire to place these works out of doors and by his choice of stainless steel, which reflects its surroundings, as his primary material. The surface of the sculpture and its atmosphere therefore become integrally linked.

Smith began silhouetting objects with spray paint in 1958–59. Placing available, diverse materials on paper, he then sprayed them with automobile enamel from varying angles,[2] allowing the area within the sprayed boundaries—the untouched paper—to become the dominant image. The resulting indefinite edges exclude evidence of the artist's hand, ordinarily so obvious in Smith's works on paper. Such anonymity was only occasionally breached, as in this work, by the addition of vigorously applied white paint within the individual elements. This highlights and enhances the weight and presence of the form on the page and refers as well to the highly gestural and burnished surfaces of his sculpture. Although the spray paintings are predominantly dark, brilliant colors were frequently introduced. The subdued earthen tones of the work in the Gallery's collection, however, encourage a reading of the space surrounding the image as landscape.[3] Typically, Smith's attention was not exclusive; while creating the spray paintings, he was also producing intimate black-ink drawings in an energetic, calligraphic style. In 1965, while he was still at the height of his powers, a tragic accident claimed his life. CB

1 Paul Cummings, *David Smith: The Drawings* (New York: Whitney Museum of American Art, 1979), p. 21.

2 Ibid., p. 34.

3 Holliday T. Day, *David Smith* (Chicago: Arts Club of Chicago, 1983), n.p.

Spray paint and tempera
16½ x 11⅝ (42 x 29.5)
Inscribed lower left in pencil: *8 ΔΣ 3-16-63*; stamped on verso
lower right: *Estate of DAVID SMITH/ACC. NO. 73-63.1*
Inv. no. 1974:5
George Cary Fund

Provenance: Estate of the artist; Knoedler Contemporary Art,
New York, 1973; purchased, 1974.

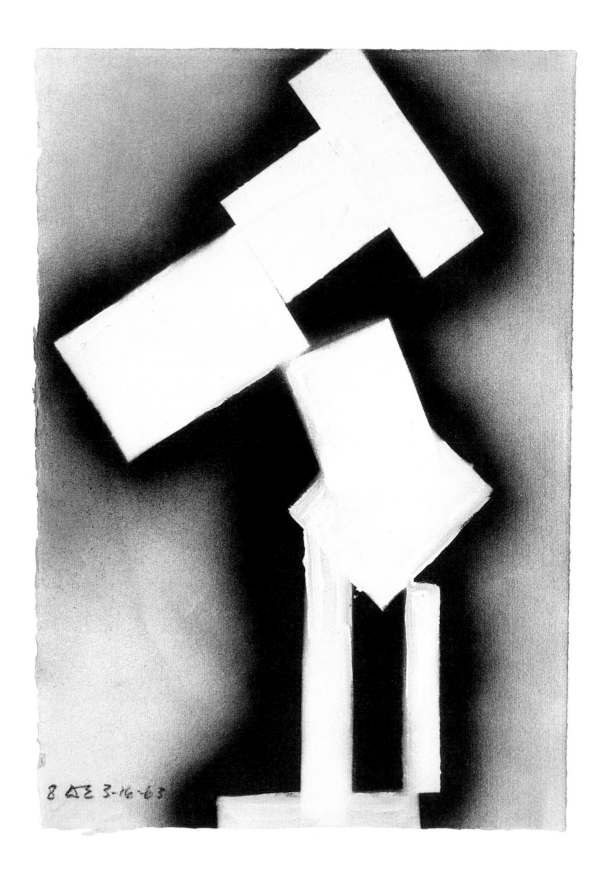

8 △Σ 3-16-63

RICHARD DIEBENKORN
American, born 1922

Untitled, 1972

This untitled drawing relates in structure and technique to a series of works that Richard Diebenkorn began in 1967. Titled "Ocean Park" after the beachfront section of Santa Monica, California, where he lives, the oil paintings and drawings in various media that comprise the series feature a spare linear structure built up through trial and error. In both his drawings and paintings, the artist's decision making remains apparent in the presence of pentimenti.

As in his oil paintings, the colors in this drawing recall the varied hues of southern California, softened by light and haze. Glints of brilliant red and blue accent the otherwise light-drenched pastel effects created by stains, drips, and white overpainting. The off-white paper, much of it untouched, not only serves as a support for the work but, in this context, also represents light and space.

Inspired by the example of Henri Matisse, Diebenkorn plays on the ambiguous relationship between interior and exterior spaces. In his representational paintings of 1955 to 1967, he often dealt with landscape seen through windows or doors. Although nonobjective, his "Ocean Park" works contain a sense both of architectural structure and of natural color, atmosphere, and light.

Frequently Diebenkorn develops a drawing over a period of time, adding a line or using a piece of paper to block out part of the work to help him resolve the composition. He thus engages simultaneously in the processes of reduction and accretion. This contemplative method results in works that convey a feeling both of immediacy and of memory by recording the steps of his creative endeavors. **HR**

Tempera, watercolor, colored chalk, and charcoal on pieced paper
27¾ x 19¼ (70.4 x 48.9)
Inscribed lower left in pencil: *R D 72*
Inv. no. 1978:2
Gift of the artist

Provenance: Presented by the artist, 1978.

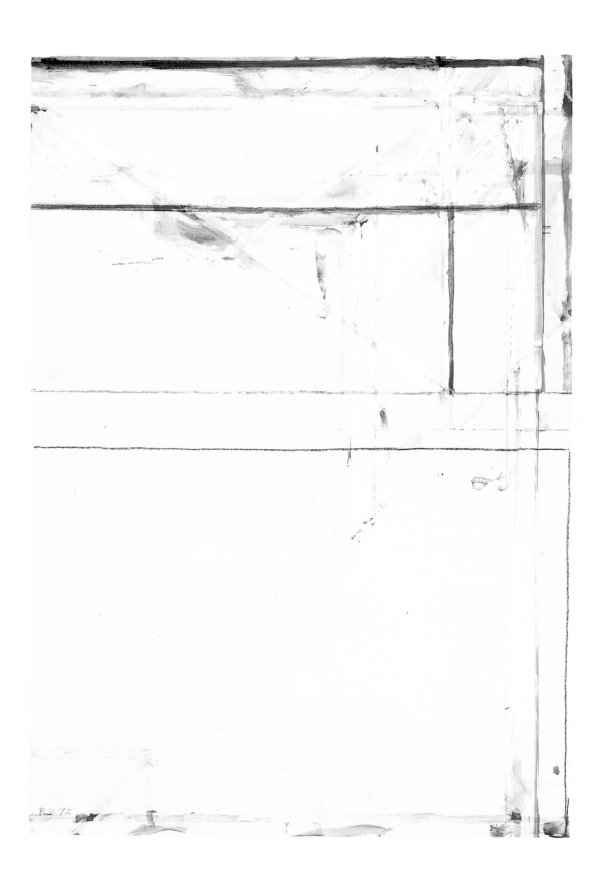

MEL BOCHNER

American, born 1940

Three Times Four, 1973

Three Times Four belongs to a seminal group of drawings that Mel Bochner created between late 1973 and 1976. These drawings form a vital link between his previous, conceptually oriented works and his more sensuous pieces of the late 1970s and 1980s.

Like his earlier works, *Three Times Four* presents elementary numerical systems in straightforward terms. Four groups, each comprising three geometric forms—a triangle, a square, and a pentagon—are distinguished from one another by differing size. Inherent in each group of three "primal" shapes, as Bochner calls them, is a basic incremental progression: three sides, four sides, five sides. Hence, if read as an equation, the title refers to the four groups of three. If read as the sum of the equation, it can refer as well to the twelve shapes in the overall drawing and to the twelve sides in any one group. In addition, although each group is arranged differently, there are visual analogies between various shapes that cause certain forms to appear to be equal in size—for example, the three-inch pentagon *seems* to be equal to the five-inch triangle—when in fact they are not. *Three Times Four* thus exposes the multiple or complex properties generated by one simple premise.

The visible layers of drawing in *Three Times Four* record the artist's progress like steps of a geometrical proof. Placed in asymmetrical arrangements, the geometric forms relate to one another in an oddly unmathematical manner and, with the pentimenti lying beneath them, the flat shapes seem to detach from the page to float in an ambiguous space. With its diverse combinations of forms, handling, and materials, the drawing has a visual richness that Bochner develops further in his later works. **HR**

Tempera and charcoal
38¹¹⁄₁₆ x 49¹⁄₁₆ (96.7 x 124.6)
Inscribed lower right in pencil: *MEL BOCHNER, 1973*
Inv. no. 1974:10
National Endowment for the Arts Purchase Grant
and Matching Funds

Provenance: From the artist to Sonnabend Gallery, New York, 1973;
purchased, 1974.

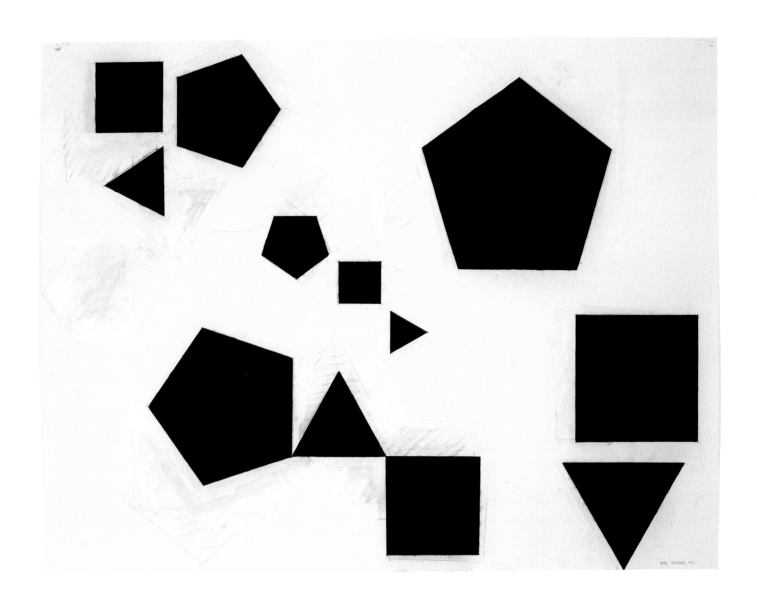

JOEL SHAPIRO
American, born 1941

Untitled, 1975–76

J oel Shapiro's untitled drawing evinces many of the same concerns that the artist addresses in his sculpture. Nevertheless, his drawings should not be dismissed as mere preliminary exercises that lead to fully developed sculptural ideas. The problems that he confronts are the same whatever the medium and, when he reaches a solution, he incorporates it into his subsequent work.

An issue of importance to Shapiro is the textural treatment of surfaces. His drawings bear the smudges and prints of his fingers. Traces of lines that have been erased or faintly drawn allude to his method of drawing, just as the marks of a mold, a pencil line, or a nail hole left on a sculpture map the process of construction. In each instance, his intuitive approach to visual expression is readily apparent, as is his desire to explore possible alternatives without eliminating any options. The challenges that he sets for himself and their numerous solutions remain visible in the finished work.

Shapiro's approach to form and space is also distinctive. He strives to heighten the sense of compressed tension in his forms by playing them off against space. This impression of concentrated energy pressing from within and without results in a charged equilibrium between space and form. Like his sculptures, his drawings, he explains, "deal with interior and exterior space. Lines are boundaries like the surface of a work: boundaries between inside and outside."[1]

The theme of interior versus exterior through the play of positive and negative space is elaborated in the Gallery's drawing. The heavy black bars may be seen as positive forms placed within a vaguely atmospheric space, or they may be read as outlines that define other forms such as the fully enclosed rectangles on the left or the partially delineated rectangles in the center and on either side.

Shapiro's focus on the physicality of the art object stems from Minimalist aesthetics, as does the spare geometric form of his work. His evident presence in the work and his improvisational handling of material, form, and space, however, deviate from the intellectually austere formalism of Minimalist art. **HR**

1 Cited in *Joel Shapiro* (Jerusalem: Israel Museum, 1981), p. 8.

Charcoal
38⅛ x 50 (97 x 127)
Not inscribed
Inv. no. 1979:20
Charles W. Goodyear Fund

Provenance: From the artist to Paula Cooper Gallery,
New York, 1979; purchased, 1979.

PIERRE ALECHINSKY
Belgian, born 1927

Triennal (Triennial), 1977

T he fluid, linear style of *Triennal* (*Triennial*) owes much to Pierre Alechinsky's interest in oriental calligraphy. Fascinated by the expressive possibilities and freedom of movement afforded by oriental techniques, Alechinsky adopted a working method modeled after that of his friend, the Chinese painter Walasse Ting. Laying paper on the floor and wielding a long-handled Japanese brush in one hand and a bowl of paint or ink in the other, Alechinsky freely and rapidly brushed in his images. After Ting introduced him to acrylic paint in 1965, his preference for paper as a support became stronger. Finding the medium conducive to spontaneous expression, Alechinsky gradually abandoned oil on canvas for acrylic and ink on various papers.

Many of Alechinsky's works of the late 1960s and 1970s were painted on small sheets of paper that were then mounted on canvas. A favorite format of those years consisted of a multicolored central image bordered by monochrome, cartoonlike "commentaries." *Triennal*, however, is painted entirely in red acrylic paint on a single large sheet of paper. Instead of a composite format, the work is organized in a three-part composition that recalls some of Alechinsky's ink drawings of the 1960s and 1970s.[1] Each section is framed by a narrow border, yet the separate parts form a coherent, unified whole.

The cryptic images that materialize from the maze of serpentine lines in *Triennal* are familiar elements of Alechinsky's imaginative personal iconography, which was influenced in part by Surrealism and the art of James Ensor and Jean Dubuffet. The key to the images lies in Alechinsky's fascination with the mysterious forces of nature. At the base of *Triennal* is a seascape crowned with turbulent, rain-filled clouds that metamorphose in the central panel into a striated jungle of tangled palms harboring hidden beasts. In the upper portion, branching trees and coiling serpents become entwined with spectral heads similar to those Alechinsky depicts emanating from the clouds of erupting volcanoes or floating in the mists of Niagara Falls.[2] As always, Alechinsky's beasts and demons enchant and intrigue rather than horrify. Physically and spiritually united with the skies and forests, the fantastic creatures of *Triennal* suggest primitive deities. AC

1 See, for example, the "Source d'information" series of 1968, particularly nos. 2 (collection of Mr. and Mrs. F. Nourissier, Paris) and 4 (Galerie La Balance, Brussels).

2 See Pierre Alechinsky, *Paintings and Writings* (Paris: Yves Rivière—Arts et Métiers Graphiques for the Museum of Art, Carnegie Institute, 1977), pp. 175, 177. Similar faces appear throughout Alechinsky's work. The serpents are among the artist's most enduring images and probably originate from his involvement in the short-lived CoBrA movement of 1949–51, a movement whose ideals continue to command his allegiance. (Although it is an acronym of Copenhagen, Brussels, and Amsterdam, the name was appreciated by the group for its aggressive reptilian associations.)

Acrylic paint on Japanese paper
85½ x 36¼ (217.1 x 92)
Inscribed lower center in wax crayon: *Alechinsky 1977*
Inv. no. K1977:11
Gift of Seymour H. Knox

Provenance: Lefebre Gallery, New York, 1977; Seymour H. Knox, Buffalo, 1977; presented, 1977.

MICHAEL SINGER

American, born 1945

First Gate Ritual Series 7/8/78, 1978

F*irst Gate Ritual Series 7/8/78* belongs to a body of work that occupied Michael Singer during the period 1976–78. "First Gate Ritual" alludes to the Japanese *torii*, a gateway to a Shinto shrine. It connotes a reverential approach to nature, which is reflected in this series of drawings and sculptures.

Long periods of time often elapse while Singer studies an environment, absorbing the ambience and channeling it into his artwork. Works in two and three dimensions develop in tandem, the ideas and images that arise in one medium stimulating experimentation in another.

Reminiscent of swaying reeds, blowing leaves, and flowing water, the abstract marks in the Gallery's drawing function like Chinese characters, each representing a concept or group of concepts. Intuitive marks recur, capture Singer's attention, and lead to a conscious exploration of their possible meanings. He explains:

The marks don't symbolize anything as concrete as a tree, but are an attempt to represent the question of: "What's behind the growth of a tree? What's the energy that makes it hold into the ground? What happens to the symbol of energy when there are vast winds? And what happens to the symbol of that energy when the winds rest in peace—when it's quiet and its only role is to be real, not to hold anything, but just to be there?" So these are all words. Those collages, they're all symbols.[1]

The formulation of a "written language" of images culled from intuitive drawings recalls the methods of the Abstract Expressionists, and the turgid force of Singer's strokes, slashes, and smears matches the tempestuous vitality of the finest Abstract Expressionist drawings. Nevertheless, beyond these similarities lies an appreciable difference. Unlike the Abstract Expressionists, who sought to convey the contents of the subconscious with spontaneous gestures, Singer strives to communicate the rhythms of nature's energy through a prolonged process of observation and experimentation. Collage elements—swatches cut from his discarded sketches—build up the surface of Singer's drawings, belying the impression of immediacy. **HR**

1 Cited in Michael Auping, *Common Ground: Five Artists in the Florida Landscape* (Sarasota, Fla.: John and Mable Ringling Museum of Art, 1982), p. 65.

Charcoal, acrylic paint, and collage
43½ x 82 (110.5 x 208.3) [including frame]
Inscribed upper left in pencil: *First Gate Ritual Series*; upper center
in pencil: *Singer*; upper right in pencil: *7 8 78*
Inv. no. 1980:21
James S. Ely Fund

Provenance: From the artist to Sperone Westwater Fischer,
New York, 1978; purchased, 1980.

NANCY GRAVES
American, born 1940

Weke, 1977

Throughout her career, Nancy Graves has created drawings of importance both in and of themselves and in relation to her work in other media. The drawings frequently introduce an idea that she subsequently develops in her sculpture, paintings, or films, as in the case of the pointillist gouache drawings of fish and insects of 1971 that led to her *Camouflage* paintings of aquatic animals made between 1971 and 1974. In these works, Graves employs naturalistic colors to indicate the patterns of pigmentation on the animals and to distinguish their shapes subtly from the environment. Her subsequent map drawings of the ocean floor, the moon, and Mars, however, demonstrate a different approach to color: various colors or tones, like a code, stand for different kinds of information about the terrain. By 1976, however, she had begun to move away from associating form and color with precise structural and descriptive references; in a series of pastels on paper completed that year, she introduced random, expressive gestures and arbitrary colors while still retaining vague allusions to the previous map works.

Weke, done in 1977, is one of a number of watercolors that mark Graves's complete liberation from systems of information or research. Freed from subject matter and predetermined structure, these energetic, fancifully colored works refer solely to themselves. Graves worked on sheets of wet paper, which required rapid execution and prevented her from engaging in her earlier, more time-consuming technique of drawing a form and filling it in. Instead, gesture and form are synonymous. Like the other watercolors of this period, *Weke* is composed of linear elements that spread out from a denser central area toward, but not quite touching, the edges of the paper. This composition enhances the effect of suspension engendered by the delicate, watery lines.

Despite the nonobjective nature of *Weke*, Graves's voracious intellectual curiosity and attachment to arcane referential sources surface in the title of the work. "Weke" is an Old Norse word that means "wet spot." At first appearing esoteric, when translated the title is revealed to be simply, even playfully, descriptive. As in all her work, here Graves tempers rational premises with a delightful sense of whimsy. **HR**

Watercolor
44 x 65⅞ (112 x 167.3)
Inscribed lower left in pencil: N. S. GRAVES '77
Inv. no. K1978:3
Gift of Seymour H. Knox

Provenance: From the artist to M. Knoedler & Co., New York, 1978;
Seymour H. Knox, Buffalo, 1978; presented, 1978.

SUSAN ROTHENBERG
American, born 1945

Untitled No. 84, 1979

Susan Rothenberg completed her first painting of a silhouetted horse in 1973 when the aesthetics of Minimalism prevailed. Unable to leave formal concerns completely behind, Rothenberg concentrated on the essence of her subject while at the same time acknowledging the expressive qualities of the painted surface. This integration of abstraction and expression brought her to the forefront of a style that is known as New Image painting. Her first images of horses were drawn against a canvas of solid color, on which she often painted crossed lines that encourage a reading of two dimensions and shallow depth—an expression of the Minimalist aversion to illusion. Essential to the success of these canvases, however, are the distillation of form, the absence of color, and the artist's highly gestural application of paint, which once again focus attention on the surface.

The image of the horse in Rothenberg's paintings became increasingly abstract throughout the 1970s until it became almost unidentifiable; by 1979, the date of the Gallery's work, the artist realized that the horse had come to serve as a self-portrait and a vehicle for the expression of extreme emotions during a period of personal crisis.

In *Untitled No. 84*, as in other works on canvas and paper, the artist's application of acrylic is agitated, revealing her emotional state. In this work, a quivering, abstracted head rushes forward, emerging from nowhere; placed above center, it appears to hover on the sheet. The paint reveals gestures that are strained and brutal, yet intimate in scale. The harshness of the image is heightened by areas that, while still wet, were slashed by the artist with a pencil, resulting in inscribed lines. The ambiguous "bone" placed horizontally in this work appears frequently in Rothenberg's canvases of the period, serving to increase the tension of the image.

By 1980 hands and heads more recognizably human emerged in Rothenberg's paintings, drawings, and prints until by the following year the image of the horse was entirely absent. Rothenberg's work reveals her willingness to seek the challenges dictated by diverse media while continuing to derive her imagery from an exploration of self. **CB**

Acrylic paint and charcoal on green paper
25⅛ x 20¼ (63.5 x 51.5)
Inscribed on verso lower left in pencil: *Susan Rothenberg/1979*
Inv. no. 1979:27
James S. Ely Fund

Provenance: From the artist to Willard Gallery,
New York, 1979; purchased, 1979.

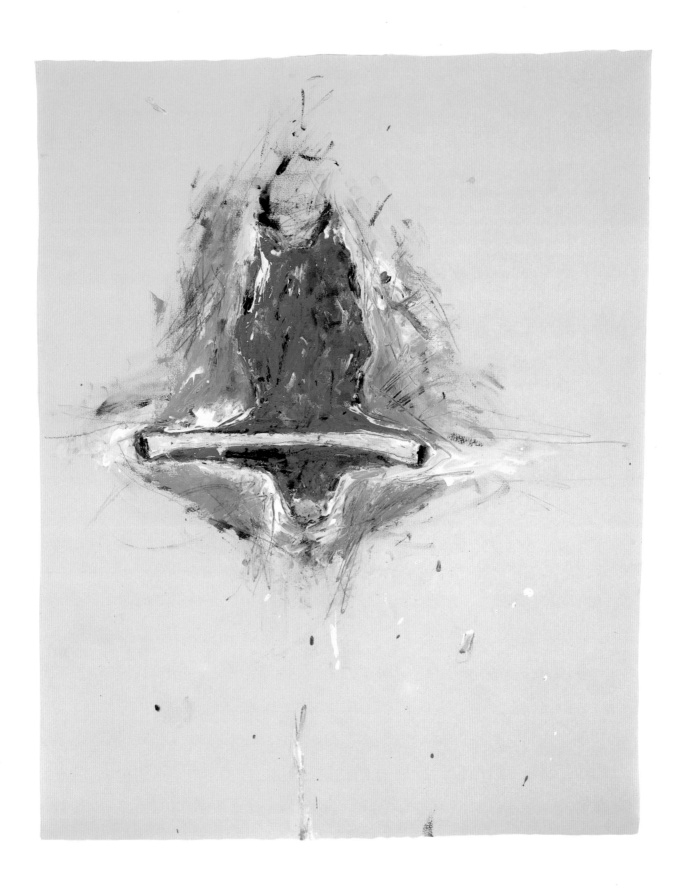

JIM DINE
American, born 1935

Untitled Black Drawing #3, 1978

Jim Dine has the uncanny ability to imbue inanimate objects simultaneously with a sense of individual character and an impersonal factuality. Ultimately, the object serves primarily as a framework on which to hang his means of expression: "I'm not depicting [the real world]," he has stated, ". . . if I'm depicting anything it's merely to get at drawing and painting in that way. I don't want to paint about nothing, you know. I'm interested in content, but the content has to be in the first place the art."[1]

During the 1960s Dine usually presented his objects out of context, isolated on canvas or paper. The still-life grouping in *Untitled Black Drawing #3* reflects his decision to return for a time to the rigors of a more traditional approach to drawing. It belongs to a series of still lifes and figure works that he executed between 1974 and 1980. Although it is common to compose a still life from studio paraphernalia, as Dine has done here, the effect of *Untitled Black Drawing #3* is unusual. Dine has placed the group of objects in a boundless darkness. As is his manner, he has richly worked the paper and thus made the atmosphere almost palpable. In contrast, many of the objects themselves appear ghostly. The artist emphasizes this impression by allowing pentimenti to create subtle auras around the glassware and by extending the intense blue glow of the bottle in the foreground beyond the perimeters of its form. The Egyptian figures share the ephemeral quality and hover in the background like phantasmagoria. Their juxtaposition with the sensual, even sexually suggestive conch shell might be interpreted as a comment on the relationships of culture and nature, past and present. The inclusion of a skull in some of Dine's other still lifes suggests that the vague allusions to *vanitas* themes may indeed be intentional. Nevertheless, the title of one of his oil paintings of the same period, *The Night Forces Painterliness to Show Itself in a Clearer Way,*[2] perhaps best explains what Dine wished to achieve in his black drawings. **HR**

[1] Jim Dine, cited in David Shapiro, *Jim Dine: Painting What One Is* (New York: Harry N. Abrams, 1981), p. 209.

[2] Janklow Collection, New York.

Pastel and paint on heavy paper
32½ x 45½ (83 x 116)
Inscribed lower left in pastel: *Jim Dine 1978*; **lower center in pastel:**
Jim Dine 1978
Inv. no. K1985:18
Gift of Seymour H. Knox

Provenance: From the artist to Pace Gallery, New York, 1978; private collection, Columbus, Ohio, 1978; Charles Foley Gallery, Columbus, Ohio, 1984; Seymour H. Knox, Buffalo, 1985; presented, 1985.

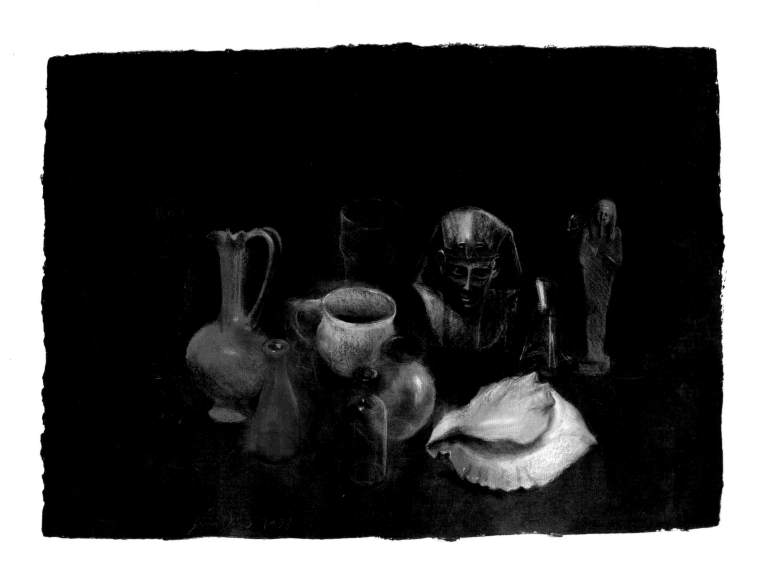

BRYAN HUNT
American, born 1947

Bequia IV, 1981

I n 1968 when he made his first trip to Europe, Bryan Hunt lost his camera almost as soon as he arrived in London. As a result, throughout his stay he relied upon drawing to record his impressions. This practice, born of necessity, established a precedent that eventually led to Hunt's continuing series of "travel drawings." For approximately the last ten years, he has made drawing an integral part of his activities during visits to different parts of the world. Any one sojourn may give rise to many small groupings of drawings, to which Hunt refers as "trios," "quartets," and "quintets." Sometimes he bases the drawings directly on a building, sculpture, landscape, or archaeological artifact that appeals to him. On other occasions, he draws entirely from his imagination, inspired by his surroundings.

Bequia IV is an example of the latter approach.[1] One of a series of five works, it demonstrates Hunt's creative response to the ambience of Bequia, a small island in the Caribbean that he visited in 1981. The sensual nature of the drawing reflects the lush subtropical setting, yet the combination of rich blacks, delicate washes, and expressive lines is characteristic of other drawings by him. Since his student days at the Otis Art Institute of Los Angeles County in the late 1960s and early 1970s, Hunt has used graphite and a mixture of linseed oil and turpentine on rag paper to achieve fluid, subtly tactile effects. In *Bequia IV* he further enhances the drawing with touches of red watercolor pencil.

Although known primarily as a sculptor, Hunt devotes as much as half of his working hours to drawing. His drawings, like his sculptures, are abstractions that suggest figures and landscapes—especially waterfalls—and often meld the two. *Bequia IV* may bring to mind water streaming into a gorge. As is typical of his work, negative space carries as much weight as positive space; here, the white of the paper can be read as either the amorphous form of water or as a wraithlike area of empty space. **HR**

1 Much of the information on *Bequia IV* was provided by Bryan Hunt in conversation with the author, 25 Sept. 1986.

Graphite, linseed oil and turpentine, watercolor pencil,
and pencil on watercolor paper
19¼ x 16⅛ (49 x 41)
Inscribed lower left in pencil: BEQIA [sic] IV;
lower right in pencil: *Bryan Hunt 81*
Inv. no. 1981:16
James G. Forsyth Fund

Provenance: From the artist to Blum Helman Gallery,
New York, 1981; purchased, 1981.

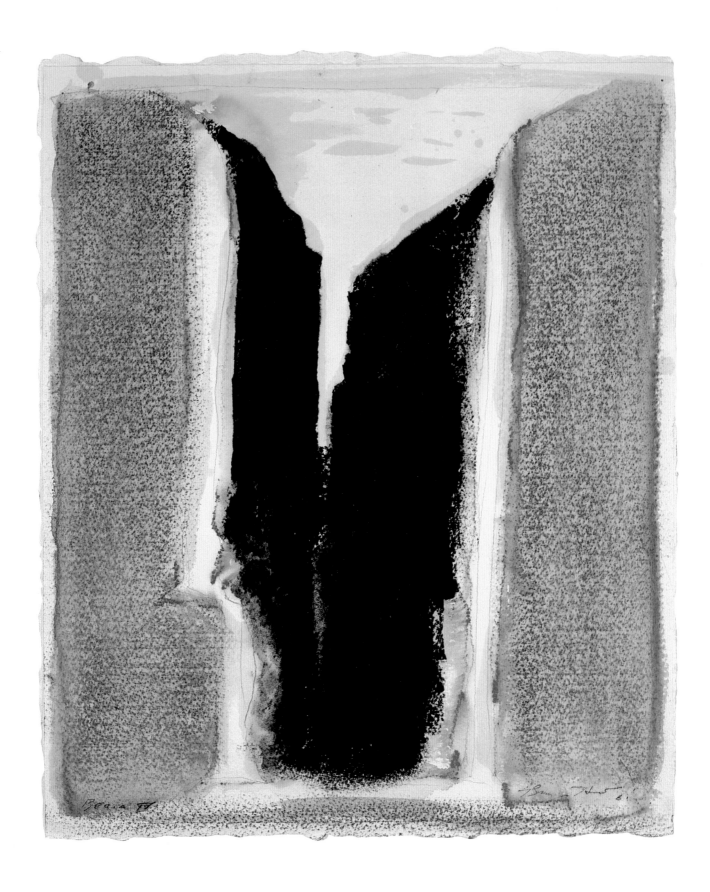

PAT STEIR
American, born 1938

At Sea, 1982

The turbulence of the ocean in Pat Steir's *At Sea* is readily apparent. Its wildly splashed blots of liquid color in brilliant greens evoke the effect of sun shining through waves, and the frenzied strokes of pale green and white oil paint in the foreground bring to mind surf breaking against rocks. Nevertheless, Steir does not allow her viewers to become seduced by an illusionistic representation of the sea. By placing the image on a grid and framing it on the page with a red line, she reminds us that this picture of the sea is actually painted marks on a flat surface.

The recognition and significance of mark making lie at the core of Steir's art. She views all marks as physical manifestations of the desire to communicate. In essence, *At Sea* serves as a diagram of different kinds of mark making. Steir mines art history to examine various masters' marks. Grids, for example, occur frequently in her work and relate to Minimalist grids in general and to those of her painter friend Agnes Martin in particular. She pairs the grid in *At Sea* with gestural marks associated with expressionism. Although the grid indicates a formalist approach while the expressionist gestures convey a spontaneous outpouring of emotion, in Steir's eyes they become equal. For her, words communicate as another form of mark making; hence, when she writes the title on a painting or drawing she considers it an integral part of the work. The title *At Sea* affects how one perceives the marks on the paper, strengthening their power to suggest a representational image.

At Sea belongs to a group of works on paper of the same title in which Steir worked over grids. Some of the grids are printed on the paper; others, as in this case, are drawn in pencil. Perhaps Steir is attracted to the sea because, like meaning, it changes incessantly yet always remains the same. She finds it an image difficult to capture and so continues to pursue it. **HR**

Watercolor, acrylic paint, oil medium, watercolor pencil and
graphite, crayon, and ink
31½ x 46⅝ (80 x 117.7)
Inscribed upper left in ink: *P. SteiR 82*
Inv. no. 1982:34
George Cary Fund

Provenance: From the artist to Nina Freudenheim Gallery,
Buffalo, 1982; purchased, 1982.

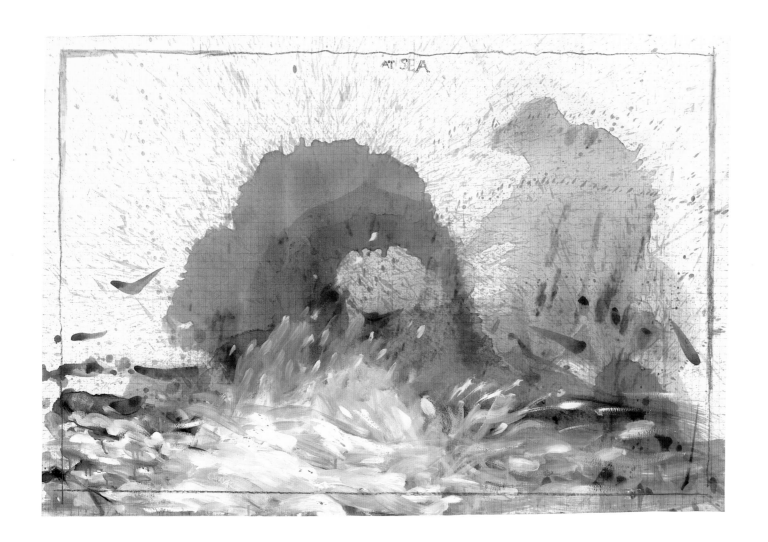

ROBERT MOSKOWITZ
American, born 1935

Untitled (White on Black), 1982

Although seemingly austere, the crisp images in the paintings and drawings of Robert Moskowitz are laden with personal associations. They reflect the artist's obsession with certain images, which, he states, "have been so stamped on my brain that they are almost abstract."[1] Having evolved out of a vision that has remained consistent, they symbolize the artist's specific emotions and relationships in a profoundly universal context.

Recently associated with New Image painting, Moskowitz has incorporated obvious description into his work since the 1960s. His minimal compositions have become grander in scale, recalling the monumental canvases of New York School painters. Yet his works also acknowledge the work of succeeding painters in their use of ordinary imagery, hard edges, and clean, uninterrupted color. Moskowitz's abiding interest in architectural spaces perhaps reveals a greater affinity for the sublime canvases of Barnett Newman or the cutouts of Henri Matisse than for Pop or Minimalism.

Since the late 1970s the artist has frequently based works on well-known architectural monuments and vernacular structures, a common theme for many early-twentieth-century photographers and painters, including the Precisionists Charles Demuth and Charles Sheeler. Yet the images in Moskowitz's work remain deeply personal. The artist's use of a subdued palette and the scale of the works—some nearing ten feet in height—contribute to their impact. The composition of *Untitled (White on Black)* is used in a larger version of the same image, also of 1982, titled *Black Mill,* and both are based on a 1981 painting of the same name (private collection). The artist's smudged pastel marks surrounding the pristine image are integral to both works, establishing a balance between the extremes of pure black and white. The severe definition of the form is emphasized by the extremely dense application of pastel within it and encourages a reading of the composition as elegant yet unsettling. **CB**

1 Robert Moskowitz, in *New Image Painting* (New York: Whitney Museum of American Art, 1978), p. 50.

Pastel and pencil on pieced paper
30⅛ x 22¼ (76.5 x 56.5)
Inscribed lower left in pencil: R M '82
Inv. no. 1983:11
Edmund Hayes Fund

Provenance: From the artist to Willard Gallery, New York, 1982; purchased, 1983.